SELECTED DRAWINGS
OF
Gian Lorenzo Bernini

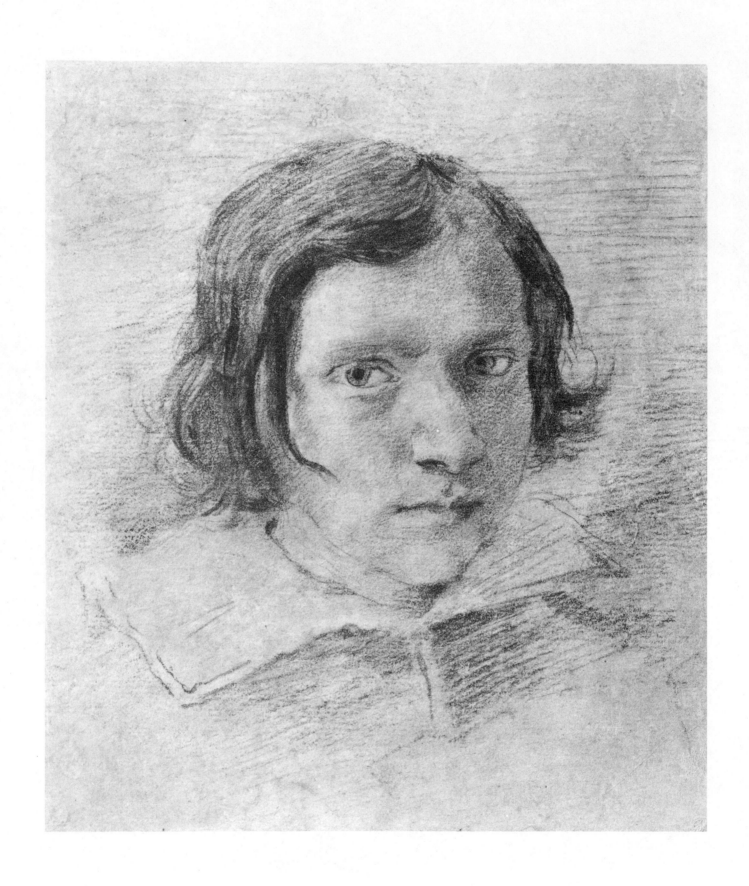

SELECTED DRAWINGS
OF
Gian Lorenzo Bernini

Edited by
ANN SUTHERLAND HARRIS

Dover Publications, Inc.
New York

Published in Canada by General Publishing Company,
Ltd., 30 Lesmill Road, Don Mills, Toronto, Ontario.
Published in the United Kingdom by Constable and
Company, Ltd., 10 Orange Street, London WC2H 7EG.

Selected Drawings of Gian Lorenzo Bernini is a new
work, first published by Dover Publications, Inc., in 1977.

International Standard Book Number: 0-486-23525-4
Library of Congress Catalog Card Number: 77-70028

Manufactured in the United States of America
Dover Publications, Inc.
180 Varick Street
New York, N.Y. 10014

INTRODUCTION

Cavalier Bernini was most singular in the arts he pursued because he possessed in high measure skill in drawing. This is clearly demonstrated by the works he executed in sculpture, painting, and architecture and by the infinite number of his drawings of the human body which are found in almost all the most famous galleries in Italy and elsewhere. . . . In these drawings one notes a marvellous symmetry, a great sense of majesty, and a boldness of touch that is really a miracle. I would be at a loss to name a contemporary of Bernini who could be compared with him in that skill.

This was the reaction of Filippo Baldinucci,[1] Bernini's first biographer, to some of the drawings by this extraordinary artist, who was described by another contemporary as "not only the best sculptor and architect of his century but, to put it simply, the greatest man as well." Bernini's position as the supreme artistic genius of seventeenth-century Italy and by far the greatest sculptor in Europe of that century is once more secure, but his reputation suffered a sharp decline in the eighteenth and nineteenth centuries as tastes veered away from the sumptuous complexity of the Roman Baroque to the disciplined purity of Neoclassicism and the archaisms of the earlier Renaissance. Bernini's work could still produce strong negative reactions early in this century. When Bernhard Berenson was shown some photographs of drawings by Bernini in the late 1920s, he professed that the very sight of them made him feel sick.[2]

Gian Lorenzo Bernini was born in Naples in 1598, the son of a minor sculptor, Pietro Bernini (1562–1629), who was working there at the time.[3] The family moved back to Rome in 1605 and Bernini lived there for the rest of his life, leaving only once for a trip to Paris in 1665.[4] His technical education came from his father, who was known for his facility as a marble carver, but his artistic education was acquired on his own in the city of Rome. He studied and made drawings after the antique from the many Roman marbles to be seen in

public sites and in private collections (Plate 2).[5] Much later, when asked which artists he admired, Bernini named Raphael, Titian, Correggio, Annibale Carracci and Guido Reni, but his work reveals that he was also much impressed by Michelangelo, with whom he was to be compared frequently. Bernini was so precocious according to his seventeenth-century biographers, who reported that he carved works on commission in his tenth year, that modern authorities have been reluctant to accept their accounts literally, but recent discoveries prove that he was paid for a public commission at the age of thirteen.[6] By the end of the second decade of the century, he was known throughout Rome as a young sculptor of prodigious gifts.

Once Bernini reached maturity, he dominated the Roman art world until his death. He did so both by virtue of the quality and originality of his prolific output and by means of his considerable executive abilities. By the mid-1620s he had established a workshop of talented assistants who not only helped him with the more mundane tasks connected with major commissions but produced other works based on his sketches that are also eloquent expressions of his ideas. Other sculptors found that there was little work left for them to do. Bernini's papal patrons also turned to him for advice about other artistic commissions, making him in effect the artistic dictator of *seicento* Rome. Urban VIII Barberini (1623–44), Innocent X Pamphili (1644–55),

Alexander VII Chigi (1655–67) and Clement IX Rospigliosi (1667–9) each in turn monopolized Bernini's services and memorialized their papacies and his artistic genius in a series of monumental commissions that gradually transformed the appearance of Rome.

Catholic pilgrims visiting the city are guided every step of the way from the Tiber River to the high altar of St. Peter's by works of Bernini created to inspire their faith. Ten angels holding symbols of the Passion of Christ designed by Bernini decorate the Ponte Sant'Angelo (1667–71; see Plate 88), where pilgrims traditionally leave the city to cross the river to the Vatican precincts. Visitors then progress to the huge oval piazza in front of St. Peter's with its majestic colonnade, built by Bernini for Alexander VII. In the portico of the church they can see Bernini's relief illustrating Christ's command to St. Peter, *Feed My Sheep!* (see Plate 31), and, to their right on the first landing of the Scala Regia, Bernini's enormous equestrian statue of *Constantine the Great*, the first Christian emperor (1654–70; see Plates 61 and 90). Once inside the vast space of the church, visitors are drawn to the massive bronze Baldacchino (1624–33; see Plates 26 and 27) built over the high altar in the center of the crossing. Behind it in the apse is the *Cathedra Petri*, a vast theatrical structure honoring the first bishop of the Church (1657–66; see Plates 71–6 and 79). The four Fathers of the Church hold aloft a huge bronze throne that actually contains an ivory chair traditionally believed to be that of St. Peter. Above them a window in the apse covered with yellow glass creates a golden light that streams into our space past a rich framework of cherubim, putti and angels. Bernini also planned the decoration of the crossing area with special balconies over the niches containing four colossal statues of Saints Longinus, Andrew, Veronica and Helen. The first of these was also carved by Bernini (1629–38; see Plates 13–20). St. Peter's also contains the tombs that Bernini designed for Urban VIII and Alexander VII and his beautiful *Altar of the Holy Sacrament* (1673–4; see Plates 92–4).

While St. Peter's and the surrounding area has the greatest concentration of works by Bernini, the rest of Rome also benefited from his creative energies. He designed a great many fountains ranging in size from the large and spectacular *Fountain of the Four Rivers* in Piazza Navona (1648–51; see Plates 47 and 48) to the modest scale of the *Fountain of the Bees* near Piazza Barberini, which resembles an open conch shell. Nearby is the *Triton Fountain* (1642–3; see Plate 37), perhaps the most perfect of all his fountain designs. He also carved a multitude of figure sculptures and portrait busts, many of them still in Roman public and private collections, and built what some believe to be the most beautiful small Baroque church in Rome, S. Andrea al Quirinale (1658–70). The public may now prefer

Bernini's fountains and his stunning early figure groups made for Cardinal Scipione Borghese, especially the virile energy of the *David* (1623–4) and the brilliant virtuosity of the *Apollo and Daphne* (1622–4). Bernini would, however, have wished to be remembered by the great religious commissions that he made for the Counter-Reformation Church. He was a devout Catholic, especially in the second half of his life, attending Mass daily and Vespers every evening in the Gesù. In effect he dedicated his enormous talents, which he believed were God-given, to the service of his Church.

The majority of Bernini's surviving drawings are connected with his sculptural and architectural commissions. They allow us to watch him thinking out loud, so to speak, as he developed his plans, though to do so requires some familiarity with the works that Bernini eventually created from these drawings. Some of his drawings were made, however, as finished works of art in their own right—the portrait drawings come especially to mind—and can be enjoyed without much background information. The works illustrated in this selection, which represents between a third and a half of Bernini's surviving graphic output, have been chosen for their beauty and variety but also for their comprehensibility. This has meant eliminating most of his schematic architectural studies, which are fascinating to architectural historians but hard for others to follow, as well as some of his rougher ink sketches for minor commissions. The choice is intended nevertheless to show all phases of Bernini's draughtsmanship from the beginning to the end of his long career and from his most incisive, brief pen sketches to his most polished and refined composition and portrait studies.

The bulk of Bernini's surviving drawings are found today in three places, Leipzig, Rome and Windsor. All three groups of drawings can be traced back to the seventeenth century, in some cases to owners who knew and admired Bernini. The Museum der bildenden Künste in Leipzig owns over two hundred autograph drawings by Bernini that probably come from the collection of Queen Christina of Sweden (1626–89).[7] The Bernini drawings in the Gabinetto delle Stampe in Rome may also come from her collection.[8] Bernini made his last piece of sculpture for her, the *Salvator Mundi* (see Plate 99), but she declined to accept it, saying that she could not afford to pay him what it was worth. The Bernini drawings in the Vatican Library come from the Chigi family, who patronized the artist in the 1650s and 1660s.[9] The Italian seventeenth-century drawings in the royal collections at Windsor Castle have an especially distinguished pedigree, for many of them can be traced from the collection of the painter Carlo Maratta (1625–1713) to that of Clement XI Albani (died 1721), then to his nephew, Cardinal Giovanni Francesco Albani, and finally to King George III.[10] Since all these collections were formed during the

latter part of Bernini's life, it may not seem surprising that drawings made in the 1650s and later are far better represented in them than drawings from the earlier decades of Bernini's career. However, it was not unusual for Italian artists to take scrupulous care of all their preparatory studies, hoarding them for years and leaving them to one trusted student or relative at their death.[11] Artists who did this have left us far more of their earlier drawings than has Bernini. It would appear in fact from the scanty and erratic rate of survival of Bernini's drawings made before the 1650s that he habitually threw many of them away when he was finished with them. His son, Domenico Bernini, tells a story about a servant who kept himself and his family for twenty years after leaving Bernini's service by selling drawings that he had picked up in the studio.[12] Many of the drawings dateable before 1650 are scattered across Europe in various print rooms and private collections. They tend to be drawings of a type originally made to be given away—finished portrait drawings presumably presented to the sitter, self-portrait drawings probably given to friends as souvenirs, preparatory studies for prints given to the engraver and finished composition studies made to show patrons what he had in mind. Nevertheless Bernini's reputation was such that others collected what he discarded. Toward the end of his life, his drawings seem to have been collected more systematically. What has been preserved is nevertheless only a small percentage of what he produced, for he was known to be a prolific draughtsman. Roughly four drawings for every year that he was active are known if we divide the length of his career (sixty-seven years) into the number of surviving drawings (roughly three hundred).

The best evidence of Bernini's cavalier attitude toward his own drawings compared with that of patrons or workshop assistants who obtained them is the difference between the number that survive of his *ad vivum* sketches for portrait busts and of his finished portrait drawings. Only two of the sketches that we know Bernini made for every bust, requiring the sitter to continue to speak and move while posing, are known today (see Plates 28 and 91) but some twenty or so autograph portrait drawings are preserved as well as many extremely skillful copies (see Plates 1, 9, 10, 22–4, etc.). Bernini evidently did not believe, as some of his contemporaries did about their drawings, that they would be useful study material for young artists, nor apparently did he want posterity to remember him in this form. Such an attitude would conform to his own idea of his artistic mission on earth. His finished works glorifying the Church were to be his memorial. The processes by which he created these masterpieces, of such great interest to us, he did not think worthy of record. His self-portraits display a similar lack of personal egotism. They are never more than simple head studies. Even in the paintings, he introduces none of the self-aggrandizing paraphernalia that characterize the self-portraits of most seventeenth-century artists.[13]

A few magnificent, carefully finished studies of the male nude of the kind that inspired Baldinucci's remarks quoted at the beginning of this essay have survived to testify, quite unnecessarily, to Bernini's mastery of the human form (see Plates 4–8 and 48), but virtuoso demonstration pieces of this kind are rare in his graphic oeuvre. Most of his drawings were made quickly; they are functional and businesslike. The process of drawing did not fascinate him in itself as it did, for example, artists like Leonardo, Parmigianino and Agostino Carracci, who constantly allowed themselves to be distracted from commissions in hand while they doodled brilliantly, and sometimes aimlessly. Bernini's drawings always go straight to the point. A survey of his graphic work creates above all the impression of a relentlessly efficient artist constantly focusing on the task in hand. His only relaxation as a draughtsman were his caricatures of friends and acquaintances, of which unfortunately few authentic examples survive (see Plates 38–41 and 100).[14]

From Bernini's surviving preparatory studies and from the small clay models (*bozzetti*) that he also made as an integral part of the planning process for all major sculpture commissions, we can reconstruct the various stages that his works passed through as they were created. He began with rough pen sketches on large sheets of paper or even charcoal sketches on the wall of the studio, as he himself later reported.[15] He also liked to try out variant poses and plans in rough pen or chalk sketches grouped together on a small sheet of paper (see Plates 20 and 47). These *primi pensieri* (first thoughts) he left if possible for a few weeks or even months in order to be able to judge them later with a fresh eye. Further composition studies followed (see Plates 3, 29, 31) until he was ready to prepare a more elaborate composition study to show to the patron concerned for his approval (see Plates 57, 60, 87, 89, 92 and 95). In the case of an especially complicated commission such as the Baldacchino and the *Cathedra Petri*, several careful composition studies might be necessary as patron and artist discussed the work and incorporated modifications (compare Plates 61 and 90).[16] Once the final design was settled, Bernini prepared *bozzetti* of the figures and even of other parts of some large monuments. For the figure of *St. Longinus* alone he is reported to have made twenty-two different *bozzetti* as he searched for the ideal pose.[17]

As poses and drapery arrangements were settled, Bernini returned to drawings as a convenient method of studying anatomical structure and drapery formations (see Plates 13–20 and 62–6 among others). The latter are always a crucial part of Bernini's compositions. He often drew a single fold or knot of drapery,

a type of sketch quite unlike the usual drapery study of the sixteenth and seventeenth centuries, which includes the whole figure with the head, hands and feet lightly sketched in.[18] For an important statue such as the *St. Longinus* or the Church Fathers supporting the *Cathedra Petri*, Bernini and the studio would next prepare a full-scale plaster model. From it assistants would begin to block out the marble. The amount of work that Bernini himself did on his sculptures varied with the importance of the commission and his age. Until the 1650s, Bernini himself did much of the final work but the studio took over an increasingly large share as he grew older. He carved almost nothing himself on the *Four Rivers Fountain*, for example, nor on the *Tomb of Alexander VII*. Bernini eventually became in fact a designer rather than a maker of sculpture. The drawings and *bozzetti* take on a special importance, therefore, as our only indication of Bernini's original intentions followed by his assistants with varying degrees of competence.

Drawings thus served three main functions for Bernini as a working sculptor. They were a quick, cheap method of visual thinking at the beginning of a project. Then they allowed him to show his ideas to his patrons as they developed. Finally they enabled him to study crucial parts of his figures from life as he completed the design. Of these three categories of drawing, only the composition studies made for patrons were drawn with another viewer in mind, the others were made for himself. The existence of a considerable number of workshop copies and versions of Bernini's final composition studies suggests that Bernini delegated the process of making them from his rough sketches to assistants, who by the 1650s were adept at imitating his pen and wash technique. These studio drawings are often of great interest nevertheless as our only records of Bernini's preliminary ideas for some commissions.[19]

We can deduce from the changes of plan recorded by various drawings and other evidence related to large works such as the *Cathedra Petri* that Bernini considered many alternatives and was willing to change his mind and even to recast complicated plans drastically. Generally as his ideas developed, they became larger, more ambitious and more original. The creative process does not seem to have been arduous for him. He left us no drawings like those of Leonardo and Michelangelo that show them reworking and retracing a configuration endlessly, apparently without finding a satisfactory solution. Bernini's drawings always look fresh and spontaneous as if, having made up his mind, he simply drew what he wanted. *Pentimenti* such as those in the Leipzig sketch for the *Feed My Sheep!* relief are rare (Plate 31). The absence of corrected lines except in rough early sketches is one indication of his phenomenal artistic intelligence, that is, his ability to focus on a

problem, grasp the essentials and set down his thoughts with clarity and precision. His mental concentration must have been remarkable. His biographers report in fact that he became quite carried away when working and would continue for hours at a stretch totally unaware of the passing time. It is this confident grasp of structure that distinguishes even his roughest preliminary sketches from those of his studio assistants or imitators. The touch of caution and stiffness that always betrays the copyist is especially evident when the work of Bernini's imitators is set beside his own.[20]

Not all of Bernini's drawings can be related to large sculptural and architectural commissions. He made designs for engravers and medallists (see Plates 25, 67, 79, 81, 82, 97 and 98). He made a number of portrait drawings in the 1620s and 1630s, some apparently casual sketches of friends or members of his own family,[21] others more finished sketches perhaps commissioned with frontispiece engravings in mind (see Plate 36). His fame as a caricaturist has already been mentioned. He also made a series of devotional drawings in the 1660s and 1670s, all of them using the basic theme of the Adoration of Christ: the Holy Family adores the Child, penitent saints in rocky wildernesses raise their arms in prayer before a crucifix laid on the ground (see Plates 83, 85, 86 and 96). These designs must have been popular because many studio variants of them are known. Their subject matter is a symptom of the intensity of Bernini's religious feelings toward the end of his life. They were surely meant to inspire their owners to pray to Christ with the fervor shown by St. Joseph and St. Jerome in the drawing.[22]

Bernini commanded an enormous range of techniques as a draughtsman. He improved on existing methods and invented new ones. He might sketch a head with a few bold, chopped strokes reminiscent of his brilliant oil sketches (see Plates 10 and 22) or spend hours carefully working over a head with black, red and white chalks, dotting, hatching, accenting, almost painting the surface to achieve effects as vividly alive as those of his famous portrait busts (see Plates 9, 23 and 35). He drew the *Cathedra Petri* with a miniaturist's precision and finesse for a medal, but also with a few imperious chalk strokes seen through the columns of the Baldacchino in order to define their spatial relationship (Plates 71 and 79). He experimented with the tonal effects possible using graphite for portrait studies (Plate 28). He tried eliminating pen lines altogether in some presentation studies, relying instead on brush and wash applied with great refinement once pale chalk guidelines had been prepared (Plate 57). In the study for the *Tomb of Cardinal Pimentel* (Plate 57) and in that for the *Catafalque of the Duke of Beaufort* (Plate 89), the washes describe the veining and the different tones of the various

marbles to be used. In his dashing study for the *Equestrian Monument of Louis XIV* (Plate 95), the washes suggest the rugged mountain up which the king's horse is ascending.

There is no better way to understand Bernini's stature as a draughtsman than to compare his drawings with those of his Italian contemporaries. The decorative, pictorial sketches of the sculptor Alessandro Algardi look merely pretty next to Bernini's bold, vigorous sketches.[23] Ottavio Leoni's elegant chalk portrait studies of Roman society, highly valued by collectors then and now, become bland and lifeless when set next to those of Bernini.[24] Only the portrait drawings of Annibale Carracci can be seen with Bernini's without suffering; indeed, they must have been an inspiration to him.[25] Bernini's academy drawings set a new fashion for this type of study. Instead of showing the models in a studio, he placed them in imaginative rocky landscape settings and gave them dramatic, energetic poses. He also drew them on a much larger scale than had been the practice before. He may have introduced these innovations in public drawing sessions at the Academy of St. Luke, of which he was *Principe* in 1630. Certainly these conventions are not found before then and are commonplace afterwards. Bernini's strange, tortured, almost clumsy pen squiggles and wash shading are unique, or were until the studio began imitating his technique in the 1650s. It later became the foundation of Giovanni Battista Gaulli's pen drawings. Neither Gaulli nor the studio, however could match the nervous energy of Bernini's staccato pen strokes nor the combination of bravura and delicacy found in his ink washes.

Bold assurance and confidence, exquisite precision, brilliance and subtlety characterize Bernini's drawings throughout his career. Then in the 1670s a more tremulous pen line than usual in some studies or blurred chalk strokes in others suggest that he was no longer able to control his right hand as completely as in the past (compare Plates 83 and 96). Nevertheless many of these late drawings are full of power. The chalk studies related to Bernini's frontispiece design for the third edition of Padre Oliva's *Sermons* issued in 1677 (Plates 97 and 98) are among the finest. Bernini's expressive figure distortions and foreshortenings, seen here in the huge bulk of the man in the foreground bending over his basket, become more marked in his last works. The study for the bust of *Christ Blessing* (Plate 99) contains one bold chalk study for the torso and a rather disappointing study of the head. Scholars are divided as to whether the head study can be explained by Bernini's declining control of his right arm or by the intervention of an assistant. We are inclined to follow the latter position.

Bernini was not idolized after his death as Michelangelo had been. His enormous success, which made it difficult for other sculptors to have careers in Rome independent of his, aroused intense jealousies as well as admiration. As tastes moved to the lightness of Rococo art and the restraint of Neoclassicism, Bernini's works were seen as heavy or ugly. Many of his drawings must have been destroyed in the eighteenth and nineteenth centuries by owners unaware of their authorship or indifferent to it. By the time Brauer and Wittkower published their famous study of Bernini's drawings in 1931, they could trace only two hundred and thirty drawings that they believed were by Bernini himself. Subsequent scholarly opinion has supported most of their conclusions, the chief criticism being that they were too severe when drawing the line between the studio and Bernini himself. A new study of Bernini's drawings is now nearing completion.[26] It will contain at least eighty more autograph drawings discovered since 1931 by scholars working in many different collections throughout Europe and in the United States, as well as a number of studio drawings of great interest.

The selection in the present volume represents a synthesis of drawings from those known to Brauer and Wittkower and those discovered since, arranged in roughly chronological order. Scholars will notice a few departures from the views of other authorities especially as regards the chronology of the portrait drawings and their identification as self-portraits but they will have to wait for the forthcoming book to learn the arguments supporting these conclusions. With one exception (Plate 99), the drawings illustrated in the present volume are all by Bernini himself except perhaps for two of the caricatures (Plates 40 and 41) and parts of two presentation composition studies where assistants probably prepared the architectural elements (Plates 60 and 90). One of the medal designs on Plate 79 may also be a studio product. Brief comments have been provided for each plate but readers are urged to consult the book by Brauer and Wittkower and Wittkower's beautifully written monograph on the sculpture for more information and good photographs of other drawings and the related sculptures. Bernini's drawings offer us many insights into his creative processes and are vivid evidence of his artistic powers but they will also lead the viewer back to the works that inspired so many of them in the first place. They are the hearty hors d'oeuvre preceding the banquet feast of his magnificent sculpture.

NOTES

1. Filippo Baldinucci, *The Life of Bernini*, translated by C. Enggass, University Park and London, 1966, pp. 73–4 and 85. The word "disegno," translated as "drawing" in the opening quotation, is also intended in its broader sense of "design." Baldinucci's *Vita del Cavaliere Gio. Lorenzo Bernino scultore, architetto, e pittore*, dedicated to Queen Christina of Sweden, was first published in Florence in 1682.

2. See the preface by Rudolf Wittkower to the reprinted edition of Heinrich Brauer and Wittkower, *Die Zeichnungen des Gianlorenzo Bernini*, Berlin, 1931; reprint, New York, 1970.

3. The literature on Bernini is enormous. The best short introduction to his work in English is Howard Hibbard's *Bernini*, Harmondsworth, 1965. For a more detailed account of his sculpture, see R. Wittkower, *Gian Lorenzo Bernini, The Sculptor of the Roman Baroque*, London, 1966.

4. His visit there at the invitation of Louis XIV, who wanted him to remodel the Louvre, resulted in few works thanks to the intrigues of local artists, but Bernini's host and escort, Paul Fréart, Sieur de Chantelou, kept a diary of the visit which is a primary source for the artist's working methods and aesthetic views (*Journal du voyage du Cav. Bernini en France*, edited by Ludovic Lalanne, Paris, 1885; all other editions are abridged and unreliable).

5. See R. Wittkower, "The Role of Classical Models in Bernini's and Poussin's Preparatory Work," *Studies in Western Art*, III, Princeton, 1963, pp. 41–50. See also Hibbard, pp. 25, 53, 173, 238 and 244.

6. Irving Lavin, "Five Youthful Sculptures by Gian Lorenzo Bernini and a Revised Chronology of his Early Works", *Art Bulletin*, 1968, pp. 223–48.

7. Brauer and Wittkower, I, pp. 12–3.

8. *Ibid.*

9. *Ibid.* The volumes then in the Chigi Palace at Ariccia are now also in the Vatican Library.

10. Anthony Blunt and Hereward Lester Cooke, *The Roman Drawings . . . at Windsor Castle*, London, 1960, pp. 7 f.

11. Domenichino is one good example of an artist who did this and whose drawings are preserved with unusual completeness as a result of his precautions and fortunate later circumstances (John Pope-Hennessy, *The Drawings of Domenichino at Windsor Castle*, London, 1948, pp. 9 f.). Andrea Sacchi's will, to be published shortly by the writer, contains similar instructions about his drawings, of which large groups exist today at Windsor and Düsseldorf.

12. Domenico Bernini, *Vita del Cavalier Gio. Lorenzo Bernino*, Rome, 1713, pp. 161–2. This biography has never been reprinted or translated.

13. Two *Self-portrait* paintings are in the Borghese Gallery, Rome; others are in the Prado, Madrid, and the Uffizi, Florence.

14. Ann Sutherland Harris, "Angelo de' Rossi, Bernini and the Art of Caricature," *Master Drawings*, XIII, 1975, pp. 158–60.

15. Chantelou, *Journal* . . . (see Note 4), June 6, 1665.

16. On the evolution of the design of the Baldacchino, see I. Lavin, *Bernini and the Crossing of St. Peter's*, New York, 1968; on the *Cathedra Petri*, see Wittkower, 1966, catalogue No. 61.

17. Joachim von Sandrart, *Teutsche Akademie . . .*, Nuremberg, 1675–9; ed. Anton Peltzer, Munich, 1925, p. 286.

18. Domenichino is a convenient example: see Plates 13, 14, 15, 16, 43, 47, etc. in Pope-Hennessy (see Note 11). For comparable examples by Lanfranco and Maratta, see Blunt and Cooke (cited in Note 10), Plates 6 and 58.

19. Brauer and Wittkower discuss almost seventy studio drawings in addition to more than two hundred autograph drawings by Bernini in their authoritative study (see Note 2).

20. Compare, for example, Plates 21 and 158 or 117 and 181a in Brauer and Wittkower, II.

21. Bernini is reported to have made a drawing of his wife but it does not survive (Brauer and Wittkower, I, p. 156, Note 2).

22. Irving Lavin's splendid article "Bernini's Death" (*Art Bulletin*, LIV, 1972, pp. 159–86) gives a full account of Bernini's religious beliefs and practices in his last years. Lavin also publishes a marble bust of *Christ Blessing* that he believes should be identified with Bernini's last work (see the comments on Plate 99).

23. Algardi's drawings were collected together in an important article by Walter Vitzthum ("Disegni di Alessandro Algardi," *Bollettino d'Arte*, 1963, pp. 75–98).

24. Bernini's own self-portrait drawings can be compared with Leoni's portrait drawing of Bernini made around 1622. For this Leoni drawing and others, see Hanno Walter Kruft, "Ein Album mit Porträtzeichnungen Ottavio Leonis," *Storia dell'Arte*, 4, 1969, pp. 447–58.

25. For two good examples, see R. Wittkower, *The Drawings of the Carracci . . . at Windsor Castle*, London, 1957, Plate 43 and Figure 27.

26. It is intended to be a companion study to Brauer and Wittkower and will publish all autograph drawings by Bernini discovered since 1931. The writer is responsible for all drawings not related to architectural commissions, which will be discussed by Dr. Alan Braham.

PHOTO SOURCES

LIST OF PLATES

Dimensions are given in millimeters (100 mm. = 3.937 inches), height before width. The reference B.W. followed by a number indicates a work illustrated in H. Brauer and R. Wittkower, *Die Zeichnungen des Gianlorenzo Bernini*, Berlin, 1931, plate volume. The reference W. followed by a number indicates the catalogue entry for the work concerned in R. Wittkower, *Gian Lorenzo Bernini, The Sculptor of the Roman Baroque*, London, 1966. The four largest groups of drawings by Bernini are in the Museum der bildenden Künste, Leipzig; the Vatican Library, Rome; the Gabinetto Nazionale delle Stampe (Accademia Nazionale dei Lincei), Rome; and the collection of H. M. the Queen at Windsor Castle. These four collections will be referred to below as Leipzig, the Vatican, Rome and Windsor respectively. A number following the location is the inventory number of the drawing in that collection. The dates given below are in most cases approximate, for few of Bernini's drawings can be dated precisely. It should be noted that the dates refer only to the drawing and are not applicable to the work of sculpture or architecture to which it may be related, which often took many years to complete.

We are grateful to the owners of these drawings who willingly gave permission to reproduce them here and who in many cases also provided us with new photographs. The author also wishes to thank Margot Wittkower for her interest and help, including a careful reading of the final text, and Mary M. Schmidt, Fine Arts Library of Columbia University, for making material available for reproduction.

[1]

PORTRAIT OF A YOUNG MAN (SELF-PORTRAIT?), c. 1615. Red and black chalk with some white heightening on buff paper, 235 by 165 mm. Florence, Horne Museum, 5567.

Self-portrait identifications have been attached to Bernini's portrait drawings too easily in the past. This drawing has not previously been published as a self-

portrait but the features of this young man come strikingly close to those of Bernini in Ottavio Leoni's print of 1622, which it would, however, predate by several years.

[2]

STUDY OF THE TORSO OF THE "LAOCOÖN," c. 1620. Red chalk with white heightening on grey paper, 359 by 247 mm. Leipzig, 62-121; B.W. 42.

Brauer and Wittkower believed that Bernini made this drawing in the 1650s when he was preparing the *Daniel* for the Chigi Chapel in S. Maria del Popolo (see Plates 62–6), but Hans Kauffmann recently suggested that it is more probably an early study after this famous antique figure group.

[3]

PLUTO AND PROSERPINE, c. 1621. Red chalk on white paper, 125 by 91 mm. Leipzig, 29-70; B.W. 5a; W. 10.

This small sketch is the earliest certainly dateable drawing by Bernini and is the only study that survives for his masterly series of figure sculptures made in the late teens and early twenties for Cardinal Scipione Borghese.

[4]

ACADEMY STUDY OF A SEATED MALE NUDE. Red and black chalk on buff paper, 570 by 435 mm. Florence, Uffizi, 11918 F.

This academy study and those that follow cannot be dated precisely. The mastery of human anatomy and technical finesse suggest that they are not beginner's drawings but rather demonstration pieces, some of them perhaps made when Bernini was associated with the Academy of St. Luke around 1630. According to Baldinucci, there were many of these splendid drawings to be seen in private collections in Rome and elsewhere but the six illustrated here (see also Plate 48) are the

only autograph examples that survive, in my opinion. Copies of high quality exist of several others.

[5]

ACADEMY STUDY OF A SEATED MALE NUDE. Red chalk with some white heightening on buff paper, 545 by 399 mm. Florence, Uffizi, 11919 F.

For comments, see Plate 4.

[6]

ACADEMY STUDY OF A STANDING MALE NUDE. Red chalk on greyish paper, 552 by 276 mm. Leipzig, 79-138; B.W. 118.

This academy study is less finished than the others and makes a more brilliant impression as a result. For further comments, see Plate 4.

[7]

ACADEMY STUDY OF A SEATED MALE NUDE. Red chalk with white heightening on white paper, 518 by 403 mm. Florence, Uffizi, 11922; B.W. 29b.

For comments, see Plates 4 and 48.

[8]

ACADEMY STUDY OF A SEATED MAN FROM THE BACK. Red chalk with partly oxydized white heightening on buff paper, 562 by 442 mm. Windsor, 5537; B.W. 119.

For comments, see Plate 4.

[9]

PORTRAIT OF A YOUNG MAN, 1625–30. Black and red chalk with some white heightening on buff paper, 316 by 230 mm. Washington, D.C., National Gallery of Art, Ailsa Mellon Bruce Fund, 1971, B-25, 774.

Though identified as a self-portrait since 1958, when it was first published, this drawing does not, in my opinion, represent the artist, whose nose was sharper, whose mouth was thinner and who was famous for his penetrating gaze. The sitter might, however, be one of Bernini's younger brothers.

[10]

PORTRAIT OF A YOUNG MAN, 1625–30. Red chalk with some white heightening on buff paper, 330 by 218 mm. Levallois-Perret, J. Petit-Horry collection.

This lively portrait sketch has an old attribution to Ludovico Carracci at the lower left. An attribution

to his cousin Annibale would have been closer the mark but this sheet lacks the painterly chiaroscuro that is found in Annibale's few portrait drawings. The bold chalk strokes and strong sense of individual psychology are typical of Bernini, though few of his surviving portrait drawings are handled as freely as this one.

[11]

GROTESQUE HEAD, 1625–30. Red chalk on buff paper, 174 by 194 mm. Düsseldorf, Kunstmuseum, FP 8910.

For comments, see Plate 12.

[12]

GROTESQUE HEAD, 1625–30. Red chalk on buff paper, 197 by 202 mm. Düsseldorf, Kunstmuseum, FP 8911.

These two grotesque heads can best be compared with the facial expressions of Bernini's *Anima Dannata* (Rome, Palazzo di Spagna, c. 1619) and that of the crying child next to Charity on his *Tomb of Urban VIII* in St. Peter's. All four heads display this extraordinary mixture of distortion and vividly observed emotion.

[13]

STUDY FOR THE TORSO OF "ST. LONGINUS," 1628–9. Red chalk on buff paper, 250 by 373 mm. Düsseldorf, Kunstmuseum, FP 7719; W. 28.

For comments, see Plate 14.

[14]

STUDY FOR THE TORSO OF "ST. LONGINUS," 1629–30. Red chalk on buff paper, 255 by 373 mm. Düsseldorf, Kunstmuseum, FP 7716; W. 28.

These two studies are related to the torso of *St. Longinus*, one of the four colossal statues in the niches of the crossing of St. Peter's. He stands facing the spectator, his right arm fully extended to the side and his left arm extended from the elbow. The short chopped strokes block out the form as if Bernini was imagining the marble beneath the paper as he drew. These are the first dateable anatomy studies by Bernini to survive; they should be compared with his later studies for *Daniel* (Plates 62–6).

[15]

TWO STUDIES FOR THE DRAPERY OF "ST. LONGINUS," 1629–30. Red chalk on buff paper, 256 by 393 mm. Düsseldorf, Kunstmuseum, FP 13260 recto; W. 28.

For comments, see Plate 18.

[16]
TWO DRAPERY STUDIES FOR "ST. LONGINUS," 1629–
30. Red chalk on buff paper, 256 by 393 mm. Düssel-
dorf, Kunstmuseum, FP 13260 verso; W. 28.

For comments, see Plate 18.

[17]
TWO STUDIES FOR THE DRAPERY BESIDE THE LEFT
ARM OF "ST. LONGINUS," 1629–30. Red chalk on buff
paper, 250 by 378 mm. Düsseldorf, Kunstmuseum,
FP 12441 recto; W. 28.

For comments, see Plate 18.

[18]
TWO STUDIES FOR THE KNOT OF DRAPERY BESIDE
THE LEFT ARM OF "ST. LONGINUS," 1629–30. Red
chalk on buff paper, 250 by 378 mm. Düsseldorf, Kunst-
museum, FP 12441 verso; W. 28.

St. Longinus wears a massive cloak that is swept up
round his torso and anchored with a large knot beside
his left elbow. This and the previous three drawings
are mainly concerned with this complicated piece of
drapery, though none shows the arrangement finally
executed.

[19]
STUDY OF A WINDOW FRAME AND OF THE LEFT
ARM OF "ST. LONGINUS," 1629. Red chalk on buff
paper, 253 by 388 mm. Düsseldorf, Kunstmuseum,
FP 12440 recto; W. 28.

In 1629 when Bernini began work on St. Longinus,
he also inherited several unfinished tasks from the
architect Carlo Maderno, who died that year. On this
sheet Bernini has made yet another sketch for part of
St. Longinus as well as doodling a window frame, prob-
ably for the Palazzo Barberini then being remodeled
along lines planned by Maderno before his death.

[20]
SHEET WITH EIGHT STUDIES FOR THE PEDIMENT OF
A DOORWAY IN THE PALAZZO BARBERINI WITH
ADDITIONAL STUDIES FOR THE LEGS OF "ST. LONGI-
NUS," 1629. Red chalk on buff paper, 275 by 367 mm.
Düsseldorf, Kunstmuseum, FP 13764; W. 28.

Here as with the drawing illustrated on Plate 19,
Bernini has used one sheet for two different purposes.
The architectural studies are all related to a doorway
in the Palazzo Barberini but the legs, evidently drawn
first, belong to St. Longinus. The technique used for
the figure study should be compared with that of the
academy study illustrated on Plate 6.

[21]
TWO STUDIES FOR A FALL OF DRAPERY FOR THE
"TOMB OF URBAN VIII," 1629–30. Red chalk on buff
paper, 246 by 341 mm. Düsseldorf, Kunstmuseum,
13951; W. 30.

A drapery study similar to those above for the St.
Longinus, this drawing seems to be related to the statue
of Urban VIII on his tomb in St. Peter's, which Bernini
started in 1629, although the entire monument was not
finished until 1647.

[22]
PORTRAIT OF A MAN WITH A MOUSTACHE, c. 1630.
Red and black chalk with partially oxydized white
heightening on grey paper, 327 by 224 mm. Windsor,
5541; B.W. 126.

Brauer and Wittkower thought that Bernini executed
this powerful portrait study toward the end of his career
but the collar style indicates a date around 1630. The
chopped, parallel strokes remind us that this is a draw-
ing by a sculptor who is constantly sensing the three-
dimensional form beneath the flat surface. The bold
assurance of this splendid drawing sets a standard that
even Bernini himself rarely matches.

[23]
PORTRAIT OF A MAN WITH A MOUSTACHE, c. 1630.
Red and black chalk with a little white heightening
on buff paper, 250 by 185 mm. Oxford, Ashmolean
Museum, Parker 792.

This beautiful drawing has been called a self-por-
trait by many authorities but the identification is not
completely convincing. This man's face is square, Ber-
nini's was oval; his nose is broad and slightly uneven
along the bridge, Bernini's was narrower and straighter.
Above all, this man's gaze lacks the fierce concentra-
tion found in Bernini's best authenticated self-portraits
and in portraits of him by other artists.

[24]
PORTRAIT OF A BOY, c. 1630. Black chalk with red
chalk accents and white heightening on grey paper, 205
by 177 mm. Windsor, 5543; B.W. 1.

Brauer and Wittkower believed that this drawing
was a self-portrait by Bernini at the age of fifteen. The
collar style indicates a date in the late 1620s or early
1630s, however, and the features do not match those of
Bernini at all. This child's face is too round and his
nose is too broad for the self-portrait label to be con-
vincing. The freedom and variety of the chalk stroke
make this a virtuoso example of Bernini's skills as a
draughtsman.

[25]

DAVID STRANGLING THE LION, 1631. Red chalk on cream paper, 211 by 145 mm. Paris, Louvre, 12093.

An unusual drawing for Bernini, this carefully finished, delicately worked red chalk study was identified by Walter Vitzthum as the preparatory drawing upon which Claude Mellan based his engraving of this subject for an edition of the poetry of Urban VIII published in 1631.

[26]

SKETCHES FOR THE TOP OF THE BALDACCHINO, c. 1631. Red chalk and pen and brown ink over chalk on grey paper, 360 by 263 mm. Vienna, Albertina, Arch. Hdz. Rom XXX, VIII, 769; B.W. 7.

For comments, see Plate 27.

[27]

SKETCH FOR THE TOP OF THE BALDACCHINO, c. 1631. Pen and ink on white paper, 208 by 239 mm. Vatican, Archivio Barberini; B.W. 8.

The design of the huge bronze canopy over the high altar of St. Peter's went through several phases. The design of the volutes that crown the huge, twisted columns evolved at a late stage after other solutions had been tried and judged unsuccessful. One of these drawings (Plate 27) is little more than a succinct thumbnail sketch of the new and final solution in embryo, the other (Plate 26) shows Bernini studying the planned arrangements in some detail. The executed design does not include the papal coat of arms at the summit shown in Plate 26 but has putti playing with the papal tiara and keys as they sit on the edge of the cornice with the scalloped hanging. There are detailed studies for the Baldacchino on the verso of the Albertina drawing (B.W. 6).

[28]

PORTRAIT SKETCH OF CARDINAL SCIPIONE BORGHESE, 1632. Graphite and red chalk on cream paper, 276 by 237 mm. New York, Pierpont Morgan Library, IV, 176. B.W. 11; W. 31.

This profile drawing for the famous bust of Cardinal Scipione Borghese is the only life study by Bernini to survive for an indubitably autograph portrait bust, although one other survives for a papal bust executed by the studio (see Plate 91). In no other portrait does Bernini create so strongly the impression of a living human presence, an effect all the more poignant to those spectators who know that the Cardinal died a few months after the bust was completed. When Bernini made these sketches, as he later told Chantelou, he liked the sitter to continue to speak, move about and gesture. The Cardinal's mouth is open in the drawing and in the bust, a detail that gives both works great spontaneity.

[29]

STUDY FOR THE "TOMB OF COUNTESS MATILDA" IN ST. PETER'S, 1634. Pen and ink with wash, 210 by 138 mm. Brussels, Royal Museum, 33.

This fluid ink and wash drawing, recently identified by Sir Anthony Blunt, contains most of the elements found in the final design (W. 33), although the proportions and many of the details differ. The top of the drawing has been cropped at a later date; the Countess stands beneath an arch above which are putti playing with her coat of arms.

[30]

THREE STUDIES OF AN ELEPHANT, 1632. Pen and brown ink on white paper, 111 by 175 mm. Rome, F.C. (Fondo Corsini) 124571; W. 71.

The Barberini wanted Bernini to make a statue for the garden of their palace using an Egyptian obelisk that was to be supported on the back of an elephant. This project was never carried out, although Bernini made a beautiful clay bozzetto for the elephant (Florence, Palazzo Corsini), and the basic idea was revived later for a similar monument built in front of S. Maria sopra Minerva (see Plate 87). The fluidity of this pen sketch indicates a dating in the early 1630s. The freely waving trunk is attached to the elephant's body in the bozzetto.

[31]

STUDIES FOR THE OVERDOOR RELIEF "FEED MY SHEEP!," 1633–4. Pen and ink on white paper, 243 by 171 mm. Leipzig, 10-21; B.W. 12; W. 34.

A good example of the rough, almost crude pen sketches that Bernini made while thinking out the design of a commission, this sketch for a relief shows several different legs for St. Peter and several different arms for Christ. The inscription below ("sopra la porta di S. Pietro") refers to the location of the relief to which the drawing is related over the main entrance door to St. Peter's.

[32]

PORTRAIT OF A MAN WITH A MOUSTACHE AND GOATEE BEARD, c. 1635. Black and red chalk with

touches of white heightening on the face and collar on buff paper, 250 by 185 mm. Oxford, Ashmolean Museum, Parker 795.

The technique of this brilliant portrait drawing differs from the chopped, blocky strokes used for the drawing illustrated on Plate 22. In this work, the chalk strokes are smaller and more delicate and respect the different textures and substances that they portray. A few dashing strokes lay in the shoulders and a background shadow.

[33]
PORTRAIT OF A MAN, c. 1635. Red and black chalk with touches of white heightening on the face and collar on buff paper, 256 by 195 mm. Frankfurt, Städelsches Kunstinstitut, 13675.

This drawing was discovered recently by Walter Vitzthum. As in the previous item, the head is more fully worked up than the torso, which is laid in with a few masterly strokes. The sitter's identity is not known.

[34]
PORTRAIT OF A MAN, c. 1635. Black and red chalk with white heightening on grey paper, 410 by 267 mm. Windsor, 5540; B.W. 9.

This is one of Bernini's most brilliant drawings with a dazzling mixture of large, broad chalk strokes used for the hair, shoulders and background and small, lightly indicated hatchings to model the planes of the face.

[35]
PORTRAIT OF SISINIO POLI, April 28, 1638. Black and red chalk with white heightening on buff paper, 268 by 207 mm. New York, Pierpont Morgan Library, IV, 174; B.W. 16.

One of the few portrait drawings of Bernini that can be securely identified and dated from an inscription on its verso, this study shows the more refined technique that the artist used for some portrait studies, presumably those commissioned rather than those made informally of friends and relatives. The sitter in this case was the eighteen-year-old son of a Roman noble family.

[36]
PORTRAIT OF OTTAVIANO CASTELLI, 1642–5. Black chalk with accents of red and white on cream paper, 246 by 190 mm. Formerly London, C. R. Rudolf collection; present location unknown.

The subject of this drawing can be identified from an engraved frontispiece portrait by Giovanni Francesco Grimaldi based on a lost drawing of Bernini published in 1641. Castelli was a playwright. Born in 1605, he was in his late thirties when Bernini drew him. On the only recorded occasion when Bernini attended one of his plays, a satire directed against Salvator Rosa performed in 1639, he is reported to have walked out before the end! The drawing suggests that amicable relations were resumed quickly.

[37]
STUDY FOR THE "TRITON FOUNTAIN," PIAZZA BARBERINI, 1642–3. Red chalk on cream paper, 362 by 240 mm. A later hand has applied a light wash to the paper around the contours of the figure, making it stand out slightly. New York, Metropolitan Museum of Art, Harry G. Sperling Fund, 1973.265; W. 32.

A recent discovery, this marvelous drawing was made for the figure of the triton blowing a conch shell who sits astride an open scallop shell supported by the interlaced bodies of dolphins on the fountain in Piazza Barberini. It shows the figure as executed with only minor differences.

[38]
CARICATURE OF CASSIANO DAL POZZO, before 1644. Pen and brown ink on cream paper, 106 by 116 mm. Rotterdam, Boymans-van Beuningen Museum, I 135.

According to the inscription in a seventeenth-century hand (but not that of Bernini), this caricature represents Cassiano dal Pozzo, secretary to Cardinal Francesco Barberini and a well-known antiquarian, scholar and patron of artists, in particular of Nicolas Poussin. The caricature was supposedly made by Bernini at the Barberini court and given by him to Alessandro Algardi, a fellow sculptor.

[39]
CARICATURE OF A PRIEST WITH A WINEGLASS AND MONEY BAG (?), 1640–5. Pen and brown ink on white paper, 150 by 104 mm. Princeton, New Jersey, Professor and Mrs. Irving Lavin.

This caricature of a hunchbacked priest, who some scholars think is sprinkling holy water with an aspergillum, appeared recently in a London salesroom with an attribution to Pier Francesco Mola. The lively pen strokes applied with varying degrees of pressure contrast with the smooth heavy lines used in the next two caricatures, which may only be copies.

[40]

CARICATURE OF A CAPTAIN IN THE ARMY OF URBAN VIII, before 1644. Pen and brown ink on white paper, 188 by 256 mm. Rome, F.C. (Fondo Corsini) 127521; B.W. 144.

A caricature of Don Virginio Orsini on the left side of the same sheet of paper (not reproduced here) is agreed by all authorities to be a copy but this carica-ture, identified by an inscription reading "Il Capitano della Compagnia de Romaneschi safraioli nella guerra di Urbano VIII," has usually been thought to be an original. The lines are slacker and smoother than those on Plates 38 and 39, however, and its presence in a collection of copies also arouses suspicion. Even if it is only a copy, it is a valuable record of Bernini's famous caricature studies.

[41]

CARICATURE OF A CLERIC, c. 1640–5. Pen and brown ink on white paper, 266 by 200 mm. Vatican, Cod. Chigi, P VI 4, f. 2 recto; B.W. 145.

This caricature is in an album containing a mixture of copies and originals, although authorities dispute the borderline between the categories. Those who accept caricatures such as this one as originals argue that the almost childish clumsiness of the drawing and the odd proportions were mannerisms deliberately adopted by Bernini when making caricatures, but the two lively, well-coordinated caricatures shown on Plates 38 and 39 suggest otherwise.

[42]

TRUTH UNVEILED BY TIME, c. 1646. Black chalk on white paper, 250 by 372 mm. Leipzig, 72-131; B.W. 20; W. 49.

This and the following drawing were made in con-nection with a sculpture group planned to contain the figures of Truth and Time. Bernini began this allegori-cal group as a private response to the criticisms circu-lating in Rome in the 1640s after the clock towers that he designed for the facade of St. Peter's had to be taken down when the foundations proved unstable. Only the figure of *Truth* was carved. It remained in Bernini's possession until his death and is now in the Villa Borghese. The pose finally adopted is close to that of the right-hand sketch in Plate 43. The figure shows the more elongated proportions typical of Ber-nini's late figure style.

[43]

STUDIES FOR A STATUE OF "TRUTH," c. 1646. Pen and ink on white paper, the left-hand sheet 190 by 130 mm., the right-hand sheet 155 by 126 mm. Leipzig, 6-12 and 27-61; B.W. 21.

These two drawings were once part of the same sheet. For additional comments, see Plate 42.

[44]

STUDY FOR THE DECORATION OF THE VAULT OF THE CORNARO CHAPEL, S. MARIA DELLA VITTORIA, by 1647. Pen and brown ink with some red chalk on white paper, 165 by 230 mm. Madrid, Biblioteca Nacional, 7817; W. 48.

This pen sketch shows Bernini's first rough ideas for the decoration of the vault of the Cornaro Chapel, which was painted for Bernini by Guidobaldo Abbatini. The ceiling was one of the first examples of painted heavenly visions in *seicento* Rome, eventually cul-minating in G. B. Gaulli's spectacular frescoes on the nave vaults of the Gesù.

[45]

STUDY FOR THE FIGURE OF "ST. TERESA" IN THE CORNARO CHAPEL, c. 1647. Red chalk on grey paper, 200 by 189 mm. Leipzig, 38v-92; B.W. 23b.

For comments, see next item.

[46]

STUDIES FOR THE FIGURE OF "ST. TERESA" IN THE CORNARO CHAPEL, c. 1647. Red chalk on grey paper, 274 by 208 mm. Leipzig, 39-93; B.W. 24a.

In addition to these studies for the head of St. Teresa in the famous sculpture group, there are drapery studies in Leipzig for the saint and for the angel who pierces her with a flaming arrow. These two bold schematic sketches view the saint's head from an angle not visible to the spectator in the church, who sees her almost in profile. The inscription "Alla Vittoria" on Plate 45 refers to the church for which the sculpture was made.

[47]

STUDIES FOR THE "FOUNTAIN OF THE FOUR RIVERS," PIAZZA NAVONA, c. 1648. Pen and ink with some black chalk on white paper, 321 by 345 mm. Leipzig, 66-125; B.W. 28; W. 50.

This sheet of *primi pensieri* (first thoughts) for the *Four Rivers Fountain* shows a variety of arrangements for the rock base. Bernini also shows the blocks of marble needed to achieve these plans. There are more finished composition studies for the final design in the Vatican (B.W. 25b and 26) and at Windsor (B.W. 27).

[48]

ACADEMY STUDY OF A SEATED MALE NUDE SEEN FROM BELOW, c. 1648. Red chalk with white heightening on rough grey paper, 524 by 386 mm. Florence, Uffizi, 11921; B.W. 31.

Two of Bernini's surviving academy studies are usually identified with the *Four Rivers Fountain* as studies for two of the four river gods who are seated on the rock formation. One of these is shown on Plate 7. Its pose comes close to that of the River Nile but the bold chalk handling indicates an earlier date than the late 1640s. The softer, more tonal chalk handling in this study fits better with the other chalk figure studies of the 1640s and 1650s (e.g., B.W. 34, 38, 43 and 44). The pose of this figure does not, however, match those of any of the river gods as shown in the clay *bozzetti* or as executed.

[49]

DESIGN FOR THE "TOMB SLAB OF CARDINAL CARLO EMMANUELE PIO," 1649–50. Pen and brown ink with brown wash on cream paper, 293 by 253 mm. Holkham Hall, collection The Earl of Leicester, II, 6; W. 82 (8).

The tomb slab was executed by the workshop for a site in the Gesù. The thin, broken pen line and delicately shaded wash are typical of Bernini's final composition studies made for patrons.

[50]

DESIGN FOR A FOUNTAIN USING A SHELL SUPPORTED BY DOLPHINS, c. 1652. Pen and brown wash on brown tinted paper, the water in blue wash, 396 by 245 mm. Windsor, 5625; B.W. 32; W. 55.

Bernini designed this fountain for the Pamphili family, who intended it for Piazza Navona, but it proved too small and was set up in the gardens of their villa on the Janiculum instead.

[51]

DESIGN FOR THE "FOUNTAIN OF NEPTUNE" AT THE PALAZZO ESTENSE, SASSUOLO, 1652. Black chalk on rough grey paper, 347 by 238 mm. Rome, Marquess of Talleyrand Collection; B.W. 34; W. 80 (5).

For comments, see Plate 54.

[52]

DESIGN FOR THE "FOUNTAIN OF NEPTUNE," SASSUOLO, 1652. Black chalk on white paper, 347 by 238 mm. Windsor, 5624 recto; B.W. 36; W. 80 (5).

For comments, see Plate 54.

[53]

DESIGN FOR THE "FOUNTAIN OF NEPTUNE," SASSUOLO, 1652. Black chalk on white paper, 347 by 238 mm. Windsor, 5624 verso; B.W. 38; W. 80 (5).

For comments, see Plate 54.

[54]

DESIGN FOR THE "FOUNTAIN OF NEPTUNE," SASSUOLO, 1652. Black chalk on white paper, 340 by 264 mm. Windsor, 5627; B.W. 37; W. 80 (5).

Plates 51–4 are drawings connected with a fountain made for the Este family palace in Sassuolo, near Modena. It was executed by local craftsmen supervised by Antonio Raggi. Unfortunately the finished work does not match the vigor and excitement of Bernini's original conception.

[55]

DESIGN FOR A FOUNTAIN WITH TWO TRITONS SUPPORTING A DOLPHIN, c. 1652. Pen and ink with wash on white paper, 270 by 190 mm. Berlin, Staatliche Kunstbibliothek, Mappe 3346, 230; B.W. 35.

For comments, see next item.

[56]

DESIGN FOR A FOUNTAIN WITH TRITONS SUPPORTING DOLPHINS, 1652–3. Pen and ink with wash on grey paper, 246 by 206 mm. Windsor, 5623; B.W. 33.

No fountains that match the designs shown on Plates 55 and 56 are known but perhaps these marvelously inventive drawings were made while Bernini was working on the Sassuolo project, which included a fountain with a figure of Galatea as well. Bernini's fertility as a decorative designer is best illustrated by his numerous fountains, executed and planned, which also help one to imagine the impact of the dramatic productions for which he planned the scenery and special effects.

[57]

DESIGN FOR THE "TOMB OF CARDINAL DOMENICO PIMENTEL" IN S. MARIA SOPRA MINERVA, 1653. Brown wash applied with a brush over graphite on cream paper, 376 by 286 mm. New York, Pierpont Morgan Library, 1958.18; W. 56.

Bernini designed this wall tomb for a narrow corridor but created the illusion of a freestanding monument by showing two of the four allegorical figures (Charity, Faith, Justice and Wisdom) as if they were seated on the far side of the monument. The final design is lower and broader in its proportions but contains most of the elements shown in this composition drawing.

[58]

STUDIES FOR THE FIGURE OF FAITH ON THE "PI-MENTEL TOMB," 1653. Black and red chalk on white paper, 232 by 337 mm. Leipzig, 78-137; B.W. 39; W. 56.

For comments, see Plate 59.

[59]

STUDIES FOR THE FIGURE OF FAITH ON THE "PI-MENTEL TOMB," 1653. Red chalk on white paper, 232 by 337 mm. Leipzig, 78-137 verso; B.W. 40; W. 56.

These sketches show Bernini refining his ideas for the figure of Faith on the right behind the weeping figure of Justice. In the final design she stands at the foot of the sarcophagus looking up at the effigy of the kneeling cardinal, her hands folded across her breast in a gesture of prayer.

[60]

PROJECT FOR A MONUMENT TO DOGE GIOVANNI CORNARO, 1653–6. Pen and brush point using brown ink, the plan and lines of the cornice drawn in graphite or black chalk, 416 by 295 mm. London, Sir Anthony Blunt Collection; W. 48.

The Cornaro family evidently intended to erect a monument to Doge Giovanni Cornaro in the family chapel of S. Nicolò da Tolentino in Venice, but it seems never to have been carried out. The design is a more three-dimensional version of the *Pimentel Tomb* (see Plate 57) with the effigy facing the viewer rather than detached from us in the profiled arrangement of the former. The architectural lines may have been laid in by a studio hand but all the sculptural elements were drawn by Bernini himself.

[61]

STUDY FOR THE "EQUESTRIAN MONUMENT OF CON-STANTINE THE GREAT," 1654. Black chalk with white heightening on grey paper, 310 by 267 mm. Madrid, Academia de San Fernando; W. 73.

The huge equestrian statue of Constantine now on the first landing of the Scala Regia next to the portico of St. Peter's was originally planned for a niche inside the church itself. In this early composition study, the niche appears in the background with the horse set precariously on the edge, leaping into our space. His head is turned back as if terrified of the vision his rider has just seen. In the executed design (see Plate 90), the horse reacts more calmly. In the 1660s, a new site was chosen and the plans adjusted accordingly.

[62]

STUDY FOR THE TORSO OF "DANIEL" IN THE CHIGI CHAPEL, S. MARIA DEL POPOLO. Black chalk on grey paper, 393 by 193 mm. Leipzig, 50-108; B.W. 43; W. 58.

For comments, see Plate 66.

[63]

STUDY FOR THE FIGURE OF "DANIEL," 1655. Red chalk on grey paper, 369 by 233 mm. Leipzig, 46-104; B.W. 44.

For comments, see Plate 66.

[64]

STUDY FOR THE FIGURE OF "DANIEL," 1655. Red chalk on grey paper, 379 by 147 mm. Leipzig, 49-107; B.W. 45.

For comments, see Plate 66.

[65]

STUDY FOR THE FIGURE OF "DANIEL," 1655. Red chalk on grey paper, 386 by 212 mm. Leipzig, 48-106; B.W. 46.

For comments, see Plate 66.

[66]

STUDY FOR THE FIGURE OF "DANIEL," 1655. Red chalk on grey paper, 379 by 147 mm. Leipzig, 49-107 verso; B.W. 47.

This beautiful series of drawings consists of studies for the figure of Daniel in the Chigi Chapel in S. Maria del Popolo in Rome. The pose of this slim, muscular torso was ultimately inspired by that of the father in the *Laocoön* group (see Plate 2) but the new context, new proportions and reinterpretation have so transformed the original source that it is almost unrecognizable.

[67]

DESIGN FOR THE REVERSE SIDE OF THE "ANNUAL MEDAL" OF 1657. Pen and brown ink with wash on white paper, approximately 150 mm. in diameter. Truro, Royal Institute of Cornwall. STUDIES FOR THE REVERSE AND OBVERSE OF THE SILVER SCUDO ISSUED FOR THE CANONIZATION OF ST. THOMAS OF VILLANOVA, 1658. Pen and ink with wash on white paper, 88 by 163 mm. London, British Museum, 1946-7-13-689b.

The first of these two medals, one of those commissioned annually by the Vatican, was issued to commemorate the plague that struck much of Italy in 1656. Sts. Peter and Paul are shown coming down from the sky to help the plague-stricken, who lie in the foreground. An avenging angel on the right chases away death, represented by a tiny skull in her left hand. The second medal shows St. Peter with the arms of Alexander VII on the obverse and St. Thomas distributing alms to the poor on the reverse.

[68]

STUDY FOR THE STATUE OF "ALEXANDER VII" IN SIENA CATHEDRAL, 1658. Black chalk on grey paper, 328 by 246 mm. Leipzig, 55-114; B.W. 51; W. 64.

A drapery study by Bernini for a statue probably entirely executed by his workshop, this drawing is the only autograph work connected with the commission. Two studio drawings (B.W. 160a and 160b) show the statue in its setting.

[69]

SKETCHES FOR THE CUPOLA OF S. TOMMASO AT CASTEL GANDOLFO, 1658. Black chalk on white paper, 420 by 294 mm. Vatican, Cod. Chigi, P VII 12, f. 13 verso; B.W. 91; B. 62 (1).

This architectural study was chosen to demonstrate Bernini's interest in the technical problems entailed in building his designs, in this case the dome of a small church near the Pope's summer residence at Castel Gandolfo. The artist's son Luigi became a successful engineer who invented a number of devices that made the erection of Bernini's huge sculptural complexes easier.

[70]

SKETCH FOR THE RESTORATION OF THE FOUNTAIN IN FRONT OF S. MARIA IN TRASTEVERE, 1658-9. Pen and ink on white paper, 135 by 201 mm. Vatican, Cod. Chigi, P VIII 17, f. 200. B.W. 101a.

This quick pen sketch was Bernini's first recorded idea for the restoration of an existing Roman fountain of conventional design. So abbreviated is his sketch that it almost amounts to a caricature.

[71]

SKETCH OF THE "CATHEDRA PETRI" SEEN THROUGH THE BALDACCHINO, c. 1657. Black chalk on white paper, 168 by 118 mm. Vatican, Cod. Chigi, a I 19, f. 42 verso; B.W. 74b; W. 61.

In this brief chalk sketch, Bernini drew two of his most famous works, the *Cathedra Petri*, which he was then planning, and the Baldacchino, through which the new monument would be seen from the body of the church. It is one of many such sketches, mainly related to architectural plans, that show him thinking spatially.

[72]

DRAPERY STUDY FOR A CHURCH FATHER SUPPORT-ING THE "CATHEDRA PETRI," c. 1660. Black chalk on grey paper, 411 by 253 mm. Leipzig, 56-115 verso; B.W. 75; W. 61.

For comments, see Plate 74.

[73]

DRAPERY STUDY FOR A CHURCH FATHER SUPPORT-ING THE "CATHEDRA PETRI," c. 1660. Black chalk with white heightening on rough grey paper, 416 by 251 mm. Leipzig, 51-109; B.W. 77; W. 61.

For comments, see Plate 74.

[74]

DRAPERY STUDY FOR A CHURCH FATHER SUPPORT-ING THE "CATHEDRA PETRI," c. 1660. Black chalk on rough grey paper, 411 by 253 mm. Leipzig 56-115 recto; B.W. 76; W. 61.

Plates 72, 73 and 74 illustrate three of the most beautiful of Bernini's drapery sketches. They display his total grasp of underlying structure as he indicates the forms with a few masterful strokes. The poses show considerable variations from the executed designs. At the top of Plate 73 is the inscription "a S. Pietro," re-ferring to the location of the sculpture.

[75]

STUDY OF A PUTTO IN THE GLORIA ABOVE THE "CATHEDRA PETRI," c. 1660. Black chalk on white paper, 296 by 227 mm. Leipzig, 58-117; B.W. 80; W. 61.

The angel shown here in the nude appears in the lower left of the window above the *Cathedra* wearing drapery. The sketch looks too rough and impromptu to be final but the pose indicated comes surprisingly close to the executed figure.

[76]

STUDIES OF PUTTI IN THE GLORIA ABOVE THE "CATHEDRA PETRI," c. 1660. Black chalk on white paper, 353 by 205 mm. Leipzig, 59-118; B.W. 81; W. 61.

These angels appear on the upper right of the win-dow amid gilded rays of light and cloud banks sur-rounding the opening.

[77]

STUDY FOR THE STATUE OF THE "MAGDALENE" IN THE CHIGI CHAPEL, SIENA CATHEDRAL, 1661. Black chalk on white paper, 244 by 133 mm. Leipzig, 29-68; B.W. 49; W. 63.

In the statue now in the chapel, the Magdalene's right foot is propped up on her symbol, the ointment jar, and the skull shown on the lower right in the drawing is eliminated. Her head is turned more toward the spectator and her drapery is rearranged in long, flowing lines extended by her left arm, which juts out from her body. Bernini outlined the main elements of her pose in this strange, rough drawing but the final conception is simpler and bolder. The inscription "a

Siena in faccia a S. Geronimo" indicates that the Magdalene stands opposite St. Jerome in the chapel.

[78]

THREE STUDIES FOR THE STATUE OF "ST. JEROME" IN THE CHIGI CHAPEL, SIENA CATHEDRAL, 1661. Pen and ink on white paper, 184 by 126 mm, 191 by 148 mm and 195 by 112 mm. Leipzig, 30-71, 25-56 and 24-54; B.W. 50; W. 63.

These three pen sketches represent Bernini's early ideas for the statue of *St. Jerome* in the same chapel as the *Magdalene* (Plate 77). The executed pose is close to that shown in the sketches; only details of proportion, anatomy, drapery and expression remain to be settled, but chalk studies showing these stages have not survived for this work. The inscriptions, "Siena," "Siena" and "al duomo di Siena" refer to the location.

[79]

DESIGN FOR THE "ANNUAL MEDAL" OF 1662. Pen and ink with wash on white paper, 78 by 75 mm. London, British Museum, 1946-7-13-689a. DESIGN FOR THE "ANNUAL MEDAL" OF 1663. Pen and ink on white paper, 272 by 201 mm. Vatican, Cod. Chigi, J VI 205, f. 264; B.W. 69b. TWO DESIGNS FOR A MEDAL COMMEMORATING THE CANONIZATION OF STS. PETER OF ALCANTARA AND MARY MAGDALENE PAZZI, 1669. Pen and bistre wash on cream paper, the sketches being 59 mm in diameter. Amsterdam, Rijksmuseum, 55:75 and 55:76.

Bernini is usually associated with large, even colossal works of sculpture. These medal designs show his ability to work successfully also on a very small scale. The earliest of these designs shows the *Cathedra Petri*, though with the upper glory of angels largely eliminated in order to fit the work into the circular format. There are a few minor differences from the executed design, which underwent constant revision during its creation. The delicacy of the pen and wash technique contrasts strikingly with Bernini's bold chalk studies for the *Cathedra* itself. The second medal issued shows the Scala Regia from the first landing. Graham Pollard has suggested that this may be a studio drawing; the execution may in fact be a little more mechanical than that of the other medal drawings illustrated here. The inscription, in black chalk, reads: "Regia. ab. Aula. ad. Domum. Dei." The last two designs for a medal of 1669 radiate the nervous energy that distinguishes an original drawing by Bernini from a copy.

[80]

ST. JOSEPH AND THE CHRIST CHILD, 1663. Red chalk and oil paint on white stucco, 1.12 m in diameter.

Ariccia, Palazzo Chigi; B.W. 115.

This drawing might almost be classified as a monochrome painting. It is a large oil sketch painted on the wall of the family chapel in the Palazzo Chigi at Ariccia and was made while Bernini was building a church for the family directly opposite the palace.

[81]

DESIGN FOR A FRONTISPIECE TO THE SECOND EDITION OF PADRE GIOVANNI PAOLO OLIVA'S "SERMONS," 1664. Black chalk with pen and ink on grey paper, 207 by 155 mm. Leipzig, 2-2; B.W. 104b.

For comments, see Plate 82.

[82]

STUDY FOR THE RIGHT FOREGROUND OF THE FRONTISPIECE DESIGN FOR PADRE OLIVA'S "SERMONS," 1664. Red chalk on white paper, 244 by 175 mm. Leipzig, 20-42; B.W. 105.

Plates 81 and 82 are studies by Bernini for a frontispiece engraving showing St. John the Baptist preaching. The engraving was made by François Spierre. In one drawing the composition is drafted in chalk and ink, in the other some of the foreground figures are studied in more detail. A much more detailed drawing must have been prepared for Spierre but it has not so far been traced. The inscription on Plate 82, "La Predica come s^a," means "the sermon as above."

[83]

ST. JEROME PENITENT, 1665. Pen and brown ink with wash over traces of black chalk, 392 by 294 mm. Paris, Louvre, 9575; B.W. 117.

This drawing exists in two versions, one in the Louvre, the other in the Chigi volumes in the Vatican (B.W. 116), both by Bernini himself. The former has an old inscription in French stating that the drawing was given by the artist to Colbert on October 19, 1665. Bernini's preoccupation with these devotional themes reflects his increasing piety as he grew older.

[84]

SELF-PORTRAIT, c. 1665. Black chalk with partly oxydized white heightening on grey paper, 413 by 271 mm. Windsor, 5539; B.W. 108.

This beautiful late self-portrait drawing shows the fierce, penetrating gaze noted by Bernini's biographers and so often absent from the portraits said to represent the artist. This drawing is usually dated around the time of his visit to Paris in 1665.

[85]

THE HOLY FAMILY, 1665–70. Pen and brown ink with dark brown wash, 165 by 165 mm. Rome, Rospigliosi-Pallavicini Gallery.

This devotional composition was probably presented by the artist to Clement IX Rospigliosi, to whose descendants it still belongs. It is an especially brilliant example of Bernini's use of pen and ink wash.

[86]

THE VIRGIN AND ST. JOSEPH ADORING THE CHRIST CHILD, c. 1667. Pen and brown ink over traces of black chalk, 137 by 201 mm. Berlin, Dahlem Museum, KdZ 20999 recto.

This drawing can be dated around 1667 from the scrap of an autograph letter on the verso. It is a rougher sketch than that shown in Plate 85 but is clearly related to a similar devotional subject. This drawing was only recently discovered in the Berlin collections by Peter Dreyer.

[87]

STUDY FOR THE ELEPHANT AND OBELISK IN PIAZZA DELLA MINERVA, 1666–7. Pen and ink with wash over black chalk on white paper, 549 by 339 mm. Vatican, Cod. Chigi, P VII 9, f. 83 recto; B.W. 111; W. 71.

Bernini's plans for a monument combining an obelisk on the back of an elephant (see Plate 30) finally came to fruition in the 1660s when another small obelisk was found in the gardens of S. Maria sopra Minerva. The nervous, broken pen line and subtle, graduated washes seen in this detail of the lower half of the sheet prove that this composition study was made by Bernini himself.

[88]

ANGEL WITH THE CROWN OF THORNS, 1667–8. Pen and ink on white paper, 114 by 70 mm. Leipzig, 32-77; B.W. 120a; W. 72.

This pen sketch shows Bernini's early ideas for a statue that exists in two versions, one by Bernini himself in the church of S. Andrea delle Fratte, the other, carved after his design by Paolo Naldini, on the Ponte Sant'Angelo. In the executed design, the *contrapposto* has been shifted but the position of the upper half of the body is much as shown in this drawing. There is a beautiful black chalk drawing in Rome (B.W. 120b) for the companion angel, who holds the superscription.

[89]

DESIGN FOR THE "CATAFALQUE OF THE DUKE OF BEAUFORT," 1669. Pen and ink with wash on white paper, 252 by 179 mm. London, British Museum, 1874-8-8-11. B.W. 121.

A design for the catafalque erected in S. Maria in Aracoeli to honor a French naval commander who died in a battle against the Turks, this drawing displays the precision and delicacy that Bernini used on occasion for important composition studies.

[90]

STUDY FOR THE FALL OF DRAPERY BEHIND THE "EQUESTRIAN MONUMENT OF CONSTANTINE THE GREAT," 1669–70. Black chalk with a few accents of red chalk on grey paper, 354 by 222 mm. Leipzig, 75-134; B.W. 72; W. 73.

Studio hands prepared the architectural setting, using a straightedge, and were also probably responsible for the horse and rider, while Bernini drew the great fall of drapery behind them. Unlike the earlier composition study (Plate 61), the statue is now shown in its final setting on the Scala Regia. The base masks a doorway, a fact that helps the spectator to appreciate the enormous scale of the monument.

[91]

PORTRAIT STUDY OF CLEMENT X ALTIERI, 1670–6. Red chalk on white paper, 348 by 238 mm. Leipzig, 65-124; B.W. 125; W. 78a.

A life study made by Bernini in connection with a half-length portrait of the Pope commissioned by his nephew, Cardinal Paluzzo Altieri, and probably identifiable with the work now in Palazzo Altieri, this drawing is one of two such studies by Bernini to survive (see Plate 28 for the other). The bust was never entirely finished and is partly the work of Bernini's assistants and so is a far less impressive work than that of Cardinal Scipione Borghese. Clement was already eighty when he became Pope but neither the pathos of old age nor any great sympathy for the sitter emerges from this beautifully structured record of his stolid features.

[92]

DESIGN FOR THE "ALTAR OF THE HOLY SACRAMENT," 1673–4. Pen and brown ink with wash on cream paper, 380 by 260 mm. Leningrad, Hermitage, 126; W. 78.

Bernini took particular care with the design of this last major commission for St. Peter's. Many autograph drawings and several clay *bozzetti* exist, most of them related to the figures of the angels on either side of the tabernacle. In this beautiful presentation composition study, full of exquisitely handled washes, the angels are shown holding the tabernacle aloft rather as

the Church Fathers support the Chair of St. Peter. They also act as candelabra. In the final design only one angel kneels on either side of the tabernacle, which the angels no longer support.

[93]

STUDY FOR AN ANGEL ON THE "ALTAR OF THE HOLY SACRAMENT," 1673–4. Ink and brush over black chalk on brown tinted paper, 144 by 168 mm. Windsor, 5560; B.W. 136b; W. 78.

For comments, see Plate 94.

[94]

STUDY FOR AN ANGEL ON THE "ALTAR OF THE HOLY SACRAMENT," 1673–4. Black chalk on white paper, 205 by 205 mm. Leipzig, 33-81; B.W. 135; W. 78.

Plates 93 and 94 show two of the nine autograph chalk and wash studies that survive as evidence of the care with which Bernini studied the angels that frame the tabernacle. The first of these is an ink drawing over chalk with no pen lines, an unusual technique that Bernini employed several times in his later career (see also Plates 57 and 96).

[95]

DESIGN FOR THE "EQUESTRIAN MONUMENT OF LOUIS XIV," c. 1673. Paper mounted on canvas, the drawing in pen and brown ink with brown washes, 270 by 385 mm. Bassano, Museo Civico, 186; W. 74.

This sheet is not only one of Bernini's most spirited, and impressive late drawings, it is also an important document for it shows this project as originally planned by Bernini. The executed monument was mutilated after it reached Versailles because the king did not like it. The head was modified and the rocks below the horse turned into flames, converting the statue into one of Marcus Curtius. It was then banished to the most distant part of the gardens.

[96]

ST. JEROME PENITENT, c. 1673. Brush and brown ink over black chalk, 156 by 222 mm. London, Witt Collection, 4752.

A recent discovery in a London salesroom, this drawing again employs brush and ink to create an especially atmospheric effect. It should be compared with Bernini's earlier drawing of St. Jerome made for Colbert (Plate 83).

[97]

THE FEEDING OF THE FIVE THOUSAND, c. 1677. Black chalk on white paper, 279 by 207 mm. Rome, F.C. (Fondo Corsini) 127484; B.W. 138.

This marvelously atmospheric chalk study shows Bernini's design for an engraved frontispiece made for the third edition of Padre Oliva's *Sermons* (see Plate 81). The print by François Spierre follows this arrangement closely. Plate 98 shows a more detailed study for the man in the foreground with the basket of bread and fish. The strange, twisted anatomy and bold foreshortenings are typical of expressive distortions found in the artist's late work.

[98]

STUDY OF A MAN WITH A BASKET FOR "THE FEEDING OF THE FIVE THOUSAND," c. 1677. Black chalk on white paper, 277 by 206 mm. Rome, F.C. (Fondo Corsini) 127485; B.W. 139.

For comments, see Plate 97.

[99]

CHRIST BLESSING, 1677. Black chalk on white paper, 171 by 254 mm. Rome, F.C. (Fondo Corsini) 127528; B.W. 142; W. 79.

This important drawing shows the design of Bernini's last piece of autograph sculpture, the *Salvator Mundi*, a half-length marble bust of Christ blessing that the artist bequeathed to Queen Christina in his will and which subsequently disappeared. Brauer and Wittkower thought that the head on the right was drawn by a studio hand, but Irving Lavin has argued recently (see Note 22 to the Introduction) that the entire sheet is by Bernini. The head is weak in a number of ways that seem hard to reconcile with Bernini's authorship, especially the dull, uncoordinated gaze and poorly realized facial structure. Such basic weaknesses do not affect the other late drawings illustrated here.

[100]

CARICATURE OF INNOCENT XI, 1676–80. Pen and ink on white paper, 114 by 180 mm. Leipzig, 26-57; B.W. 148.

Making caricatures hardly seems in character for Bernini's last, devout years, especially caricatures of a Pope, but the drawing seems to be autograph, and if the subject has been correctly identified, it must date from the last years of Bernini's life; Innocent XI was Pope from 1676 until 1689.

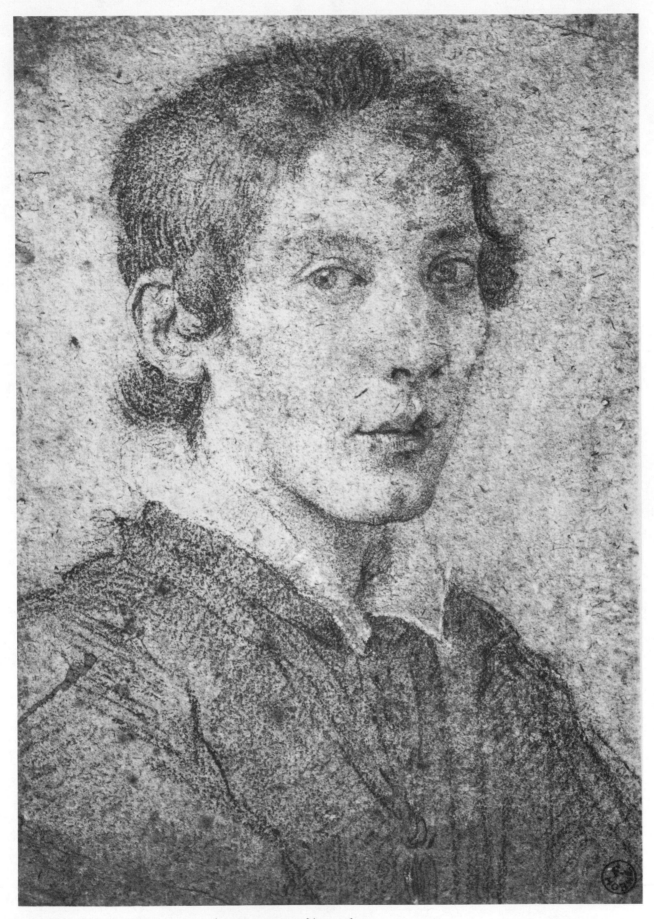

1 PORTRAIT OF A YOUNG MAN (SELF-PORTRAIT?), c. 1615

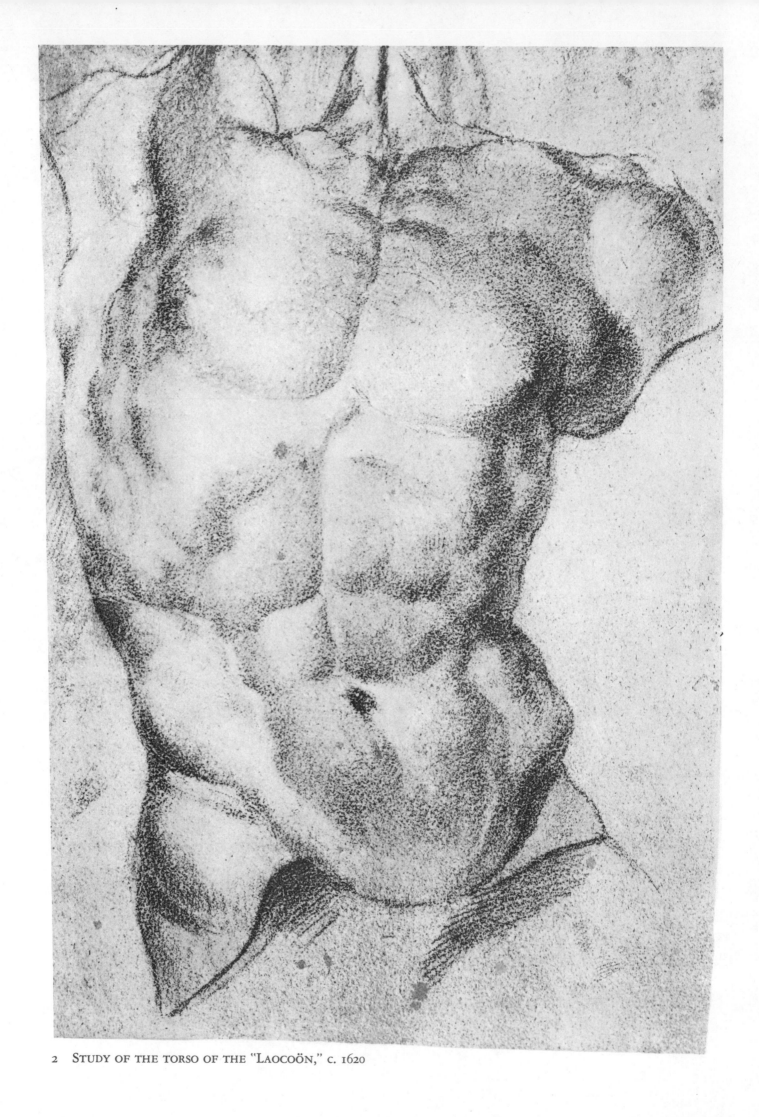

2 STUDY OF THE TORSO OF THE "LAOCOÖN," C. 1620

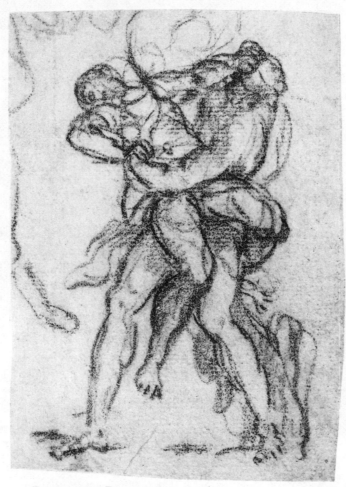

3 PLUTO AND PROSERPINE, c. 1621

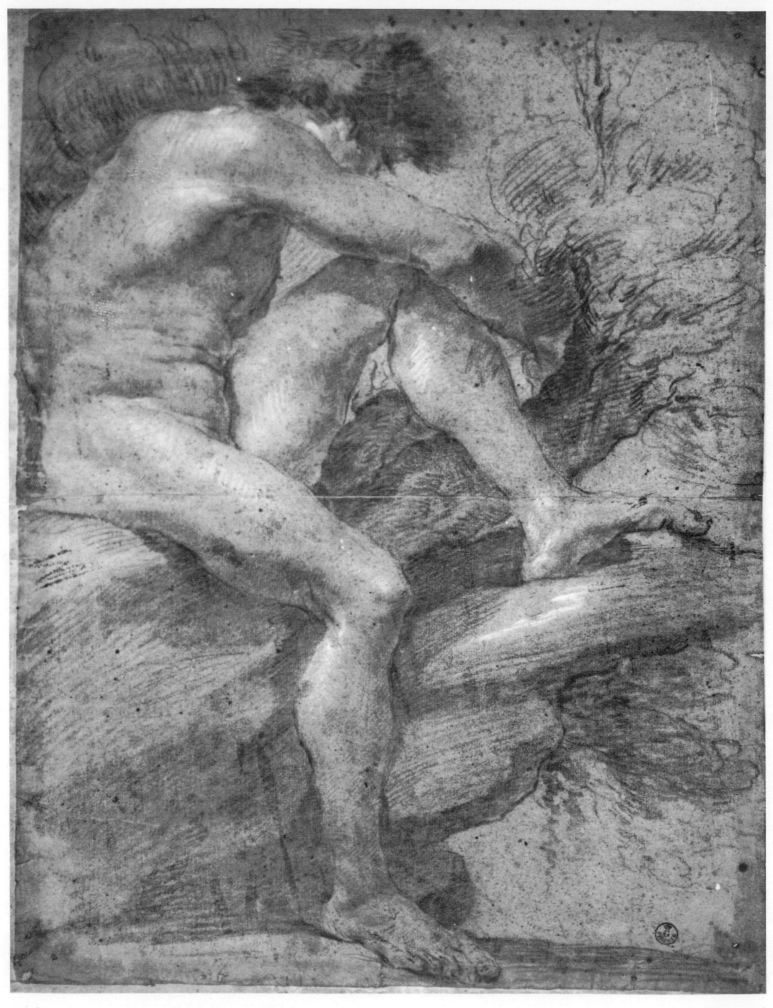

4 ACADEMY STUDY OF A SEATED MALE NUDE

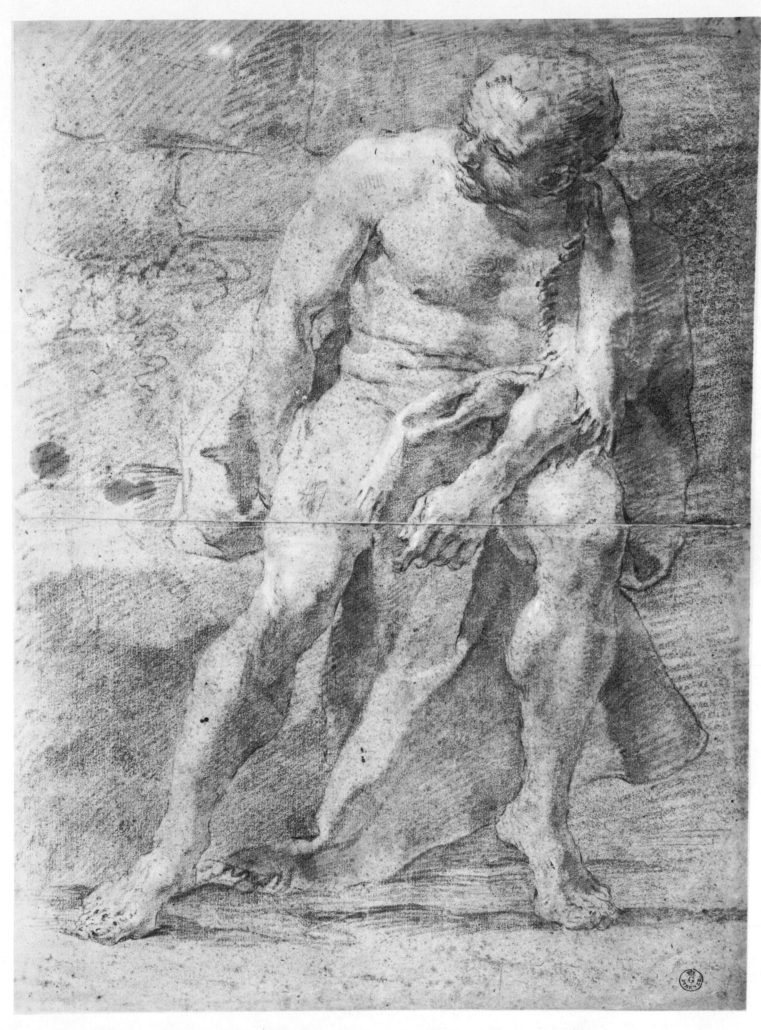

5 ACADEMY STUDY OF A SEATED MALE NUDE

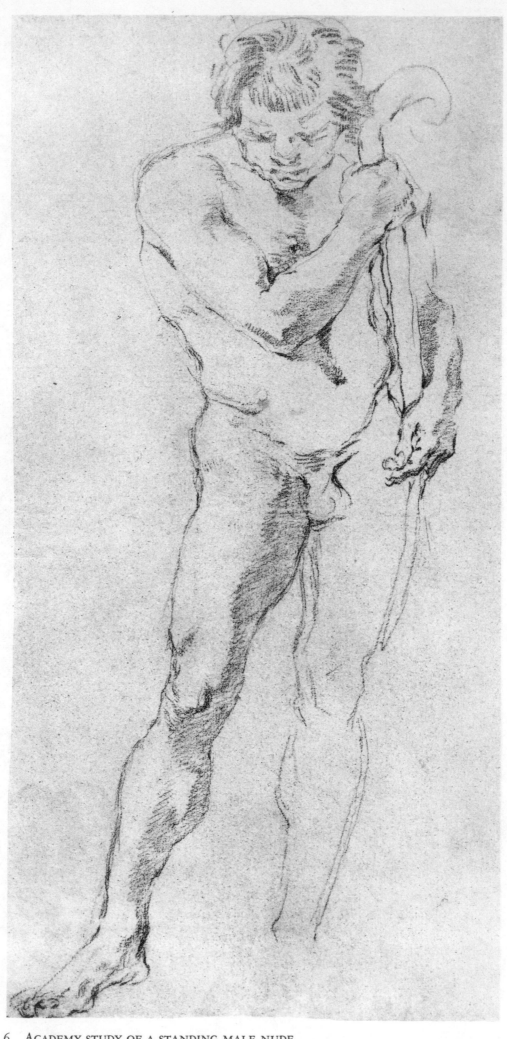

6 ACADEMY STUDY OF A STANDING MALE NUDE

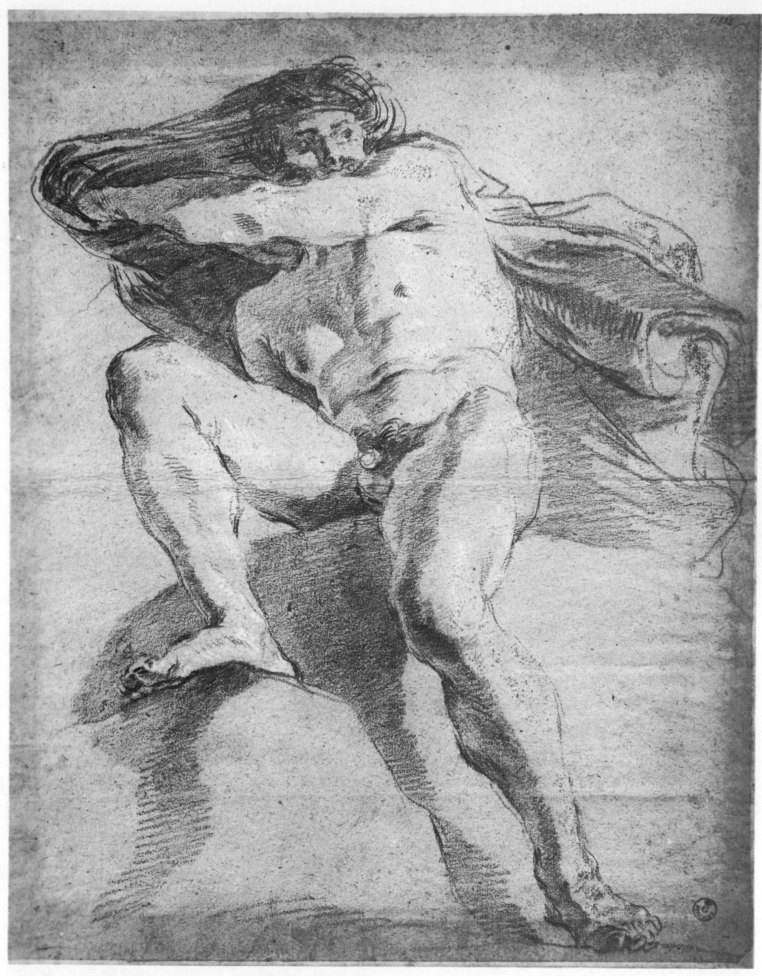

7 ACADEMY STUDY OF A SEATED MALE NUDE

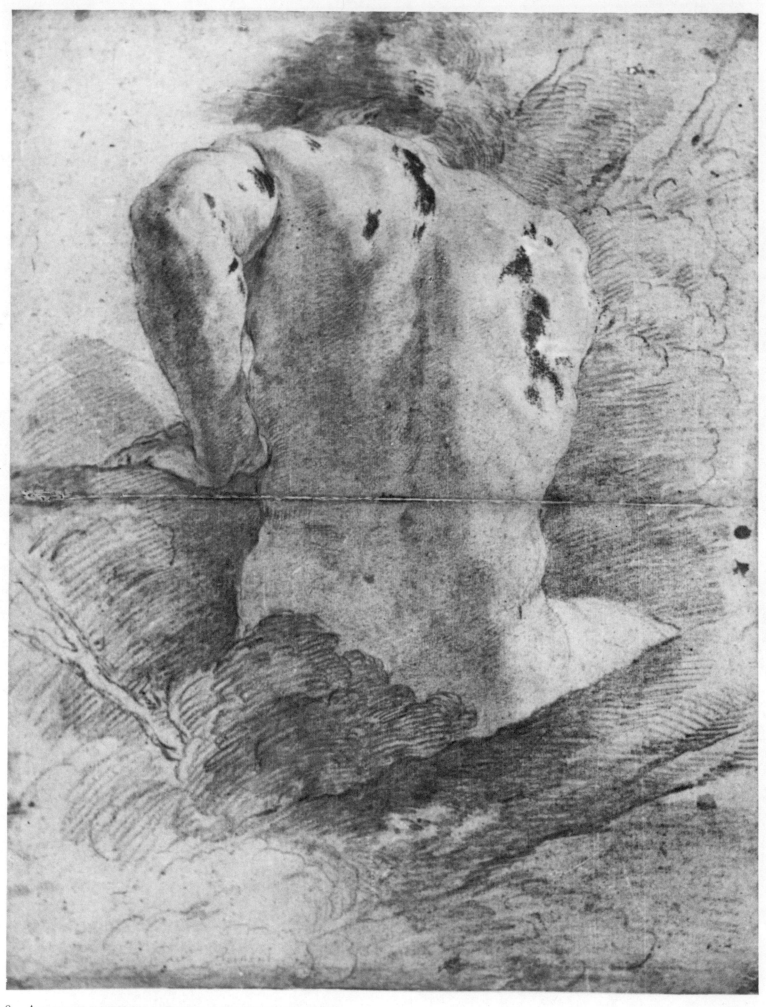

8　ACADEMY STUDY OF A SEATED MAN FROM THE BACK

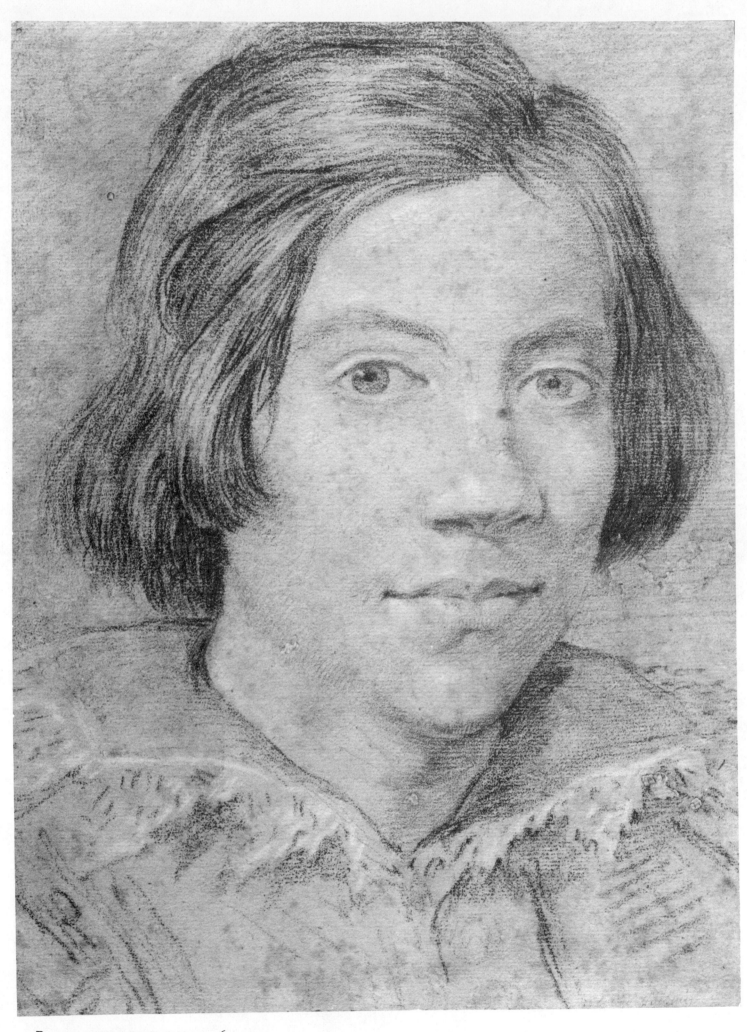

9 PORTRAIT OF A YOUNG MAN, 1625–30

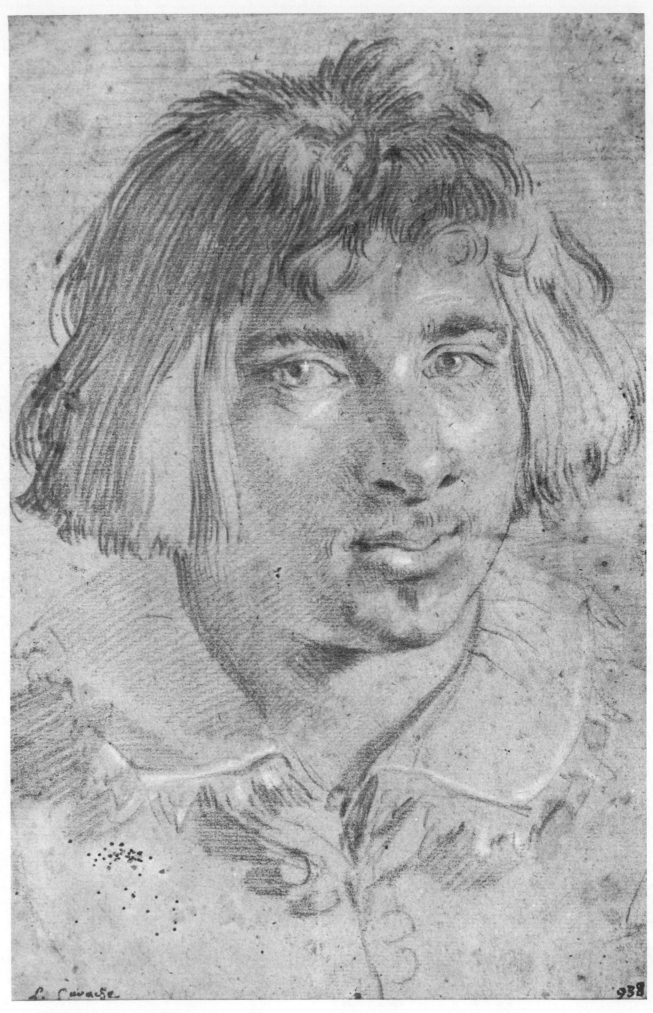

10 PORTRAIT OF A YOUNG MAN, 1625–30

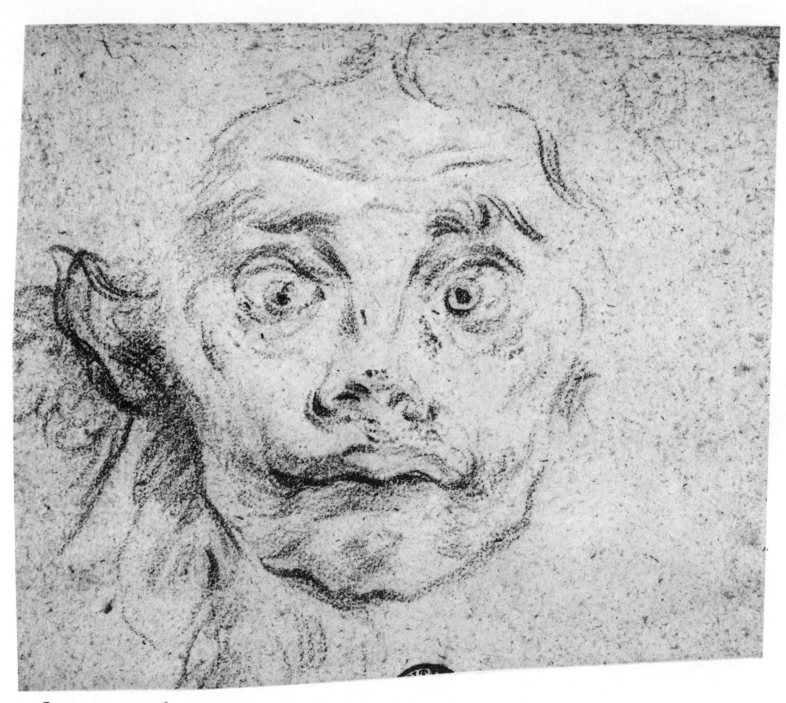

11 GROTESQUE HEAD, 1625–30

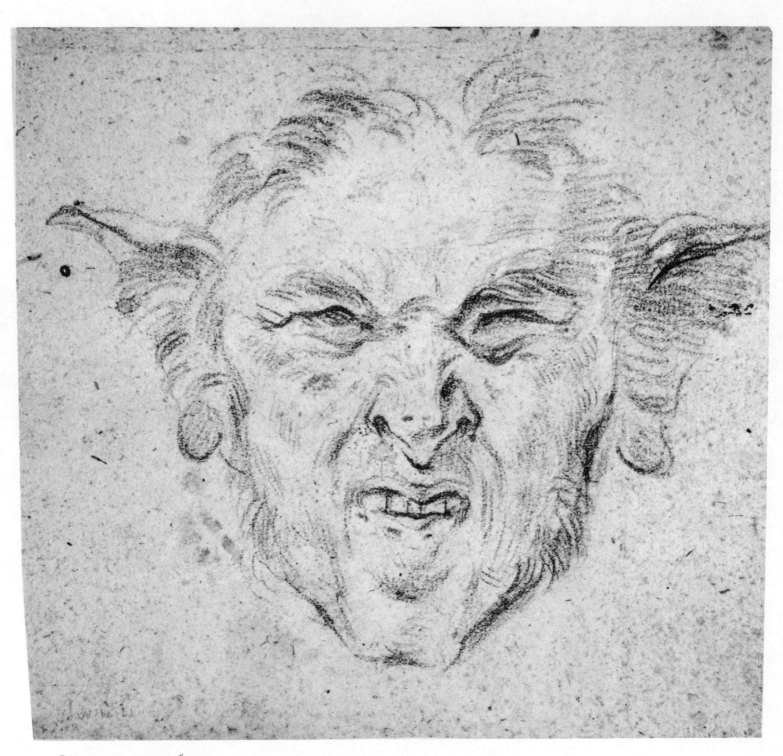

12 GROTESQUE HEAD, 1625–30

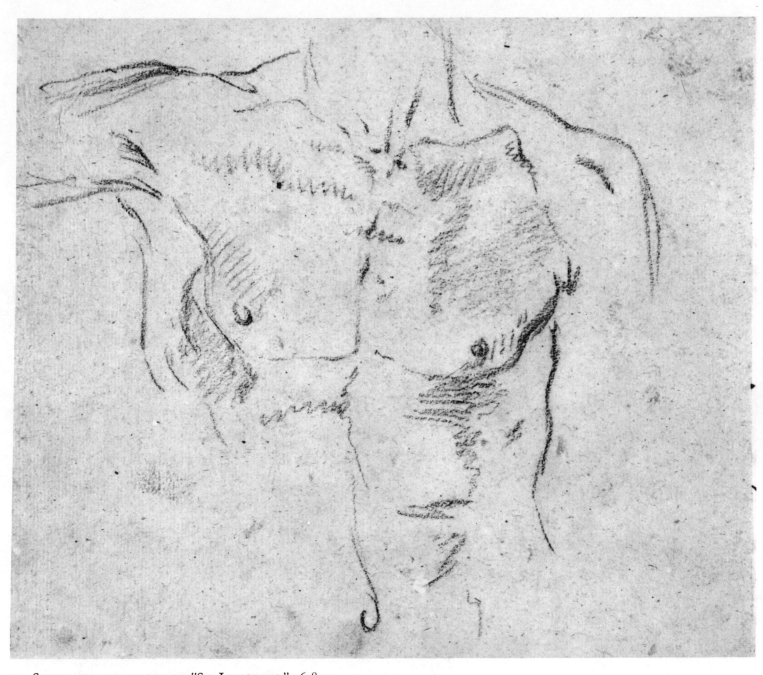

13 Study for the torso of "St. Longinus," 1628–9

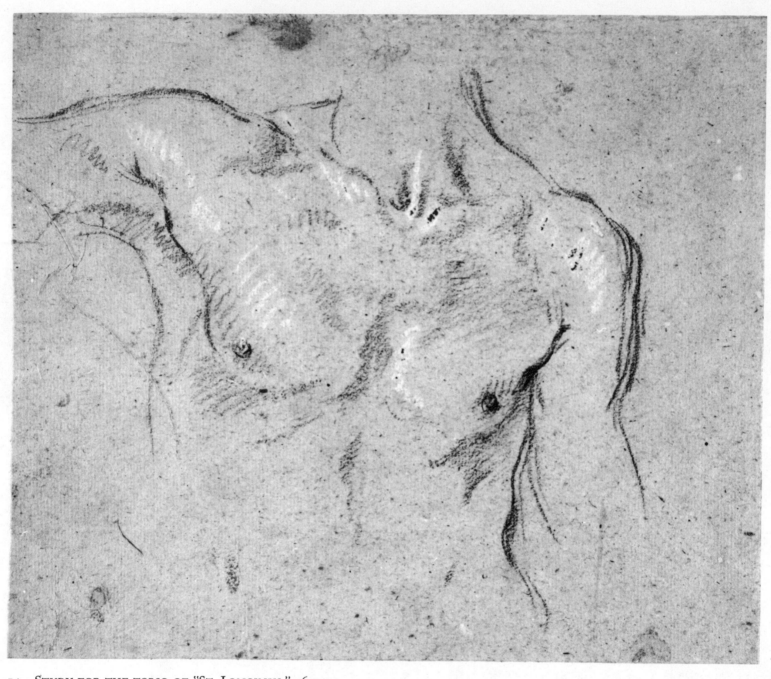

14　Study for the torso of "St. Longinus," 1629–30

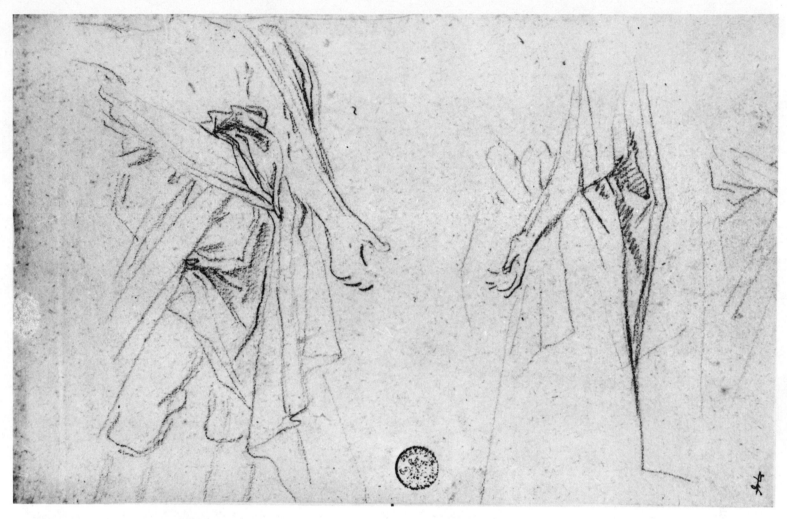

15 TWO STUDIES FOR THE DRAPERY OF "ST. LONGINUS," 1629–30

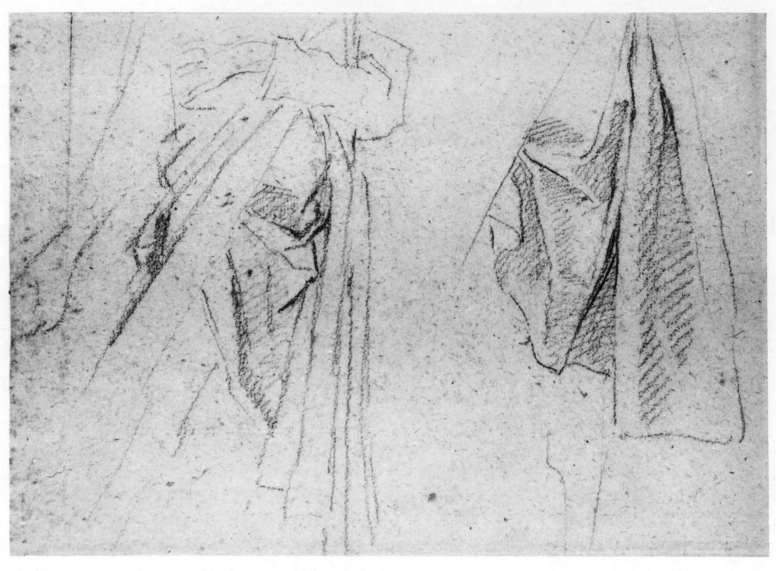

16 Two drapery studies for "St. Longinus," 1629–30

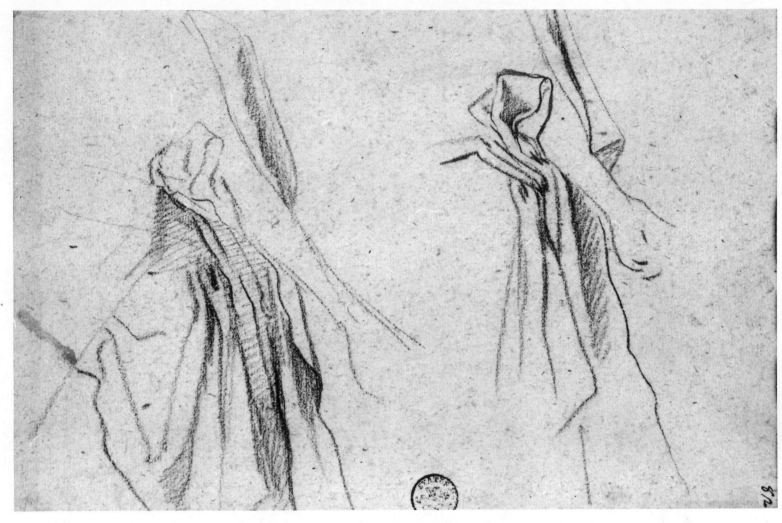

17 TWO STUDIES FOR THE DRAPERY BESIDE THE LEFT ARM OF "ST. LONGINUS," 1629–30

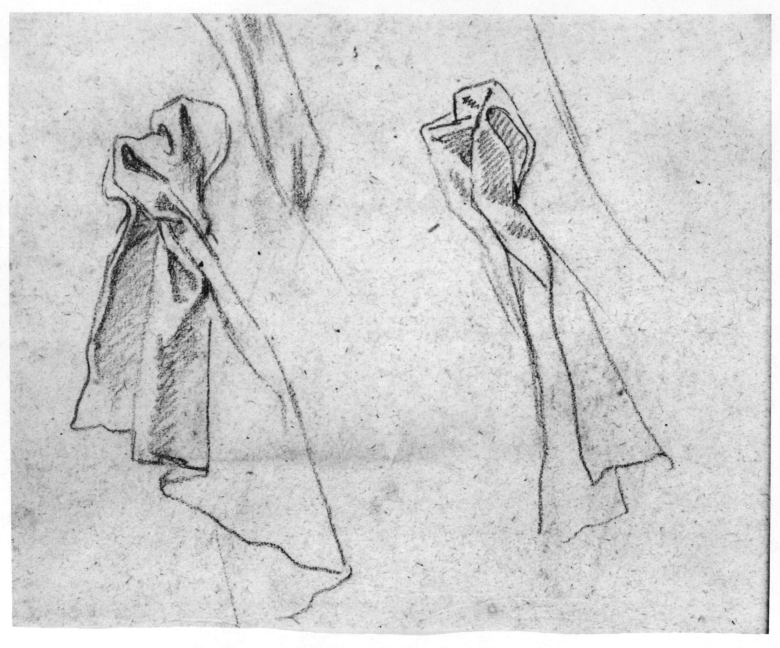

18 TWO STUDIES FOR THE KNOT OF DRAPERY BESIDE THE LEFT ARM OF "ST. LONGINUS,"
1629–30

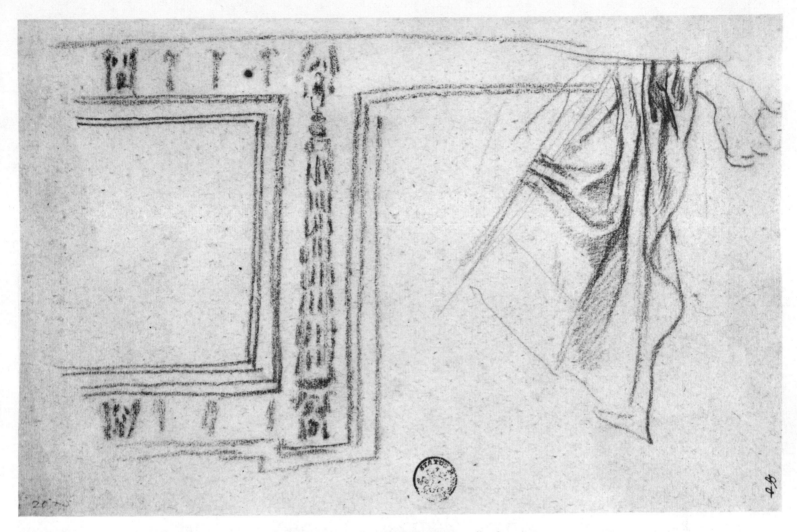

19 STUDY OF A WINDOW FRAME AND OF THE LEFT ARM OF "ST. LONGINUS," 1629

20 SHEET WITH EIGHT STUDIES FOR THE PEDIMENT OF A DOORWAY IN THE PALAZZO
 BARBERINI WITH ADDITIONAL STUDIES FOR THE LEGS OF "ST. LONGINUS," 1629

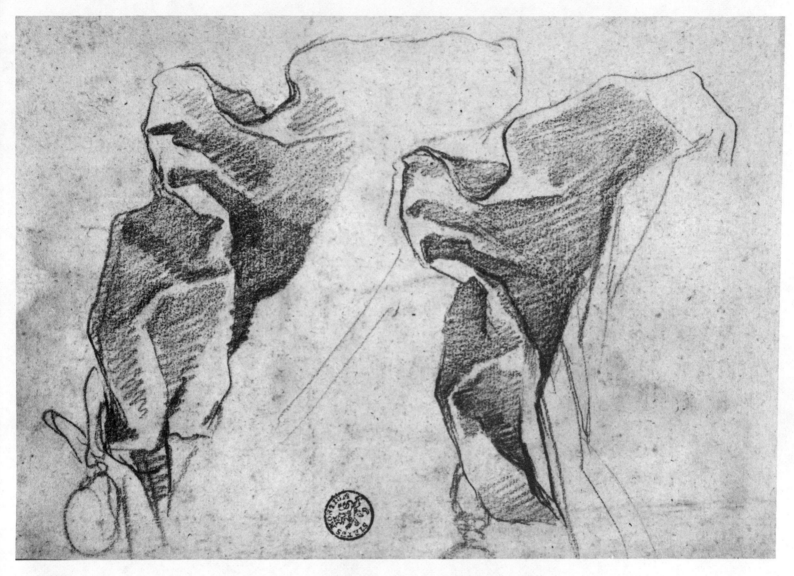

21 TWO STUDIES FOR A FALL OF DRAPERY FOR THE "TOMB OF URBAN VIII," 1629–30

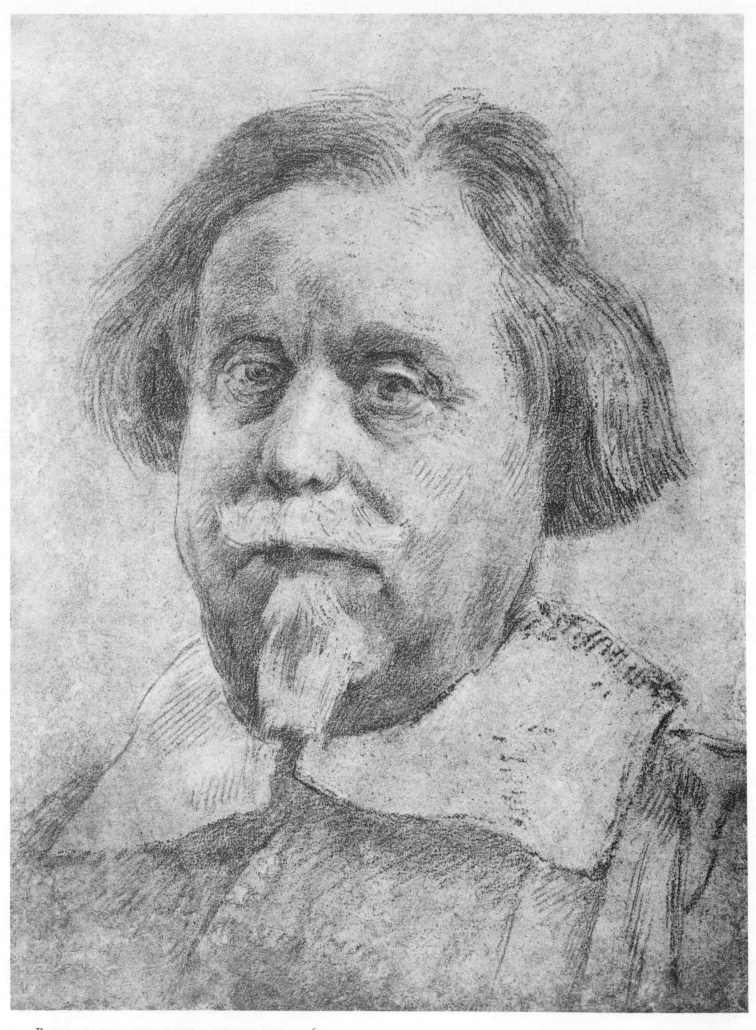

22 PORTRAIT OF A MAN WITH A MOUSTACHE, c. 1630

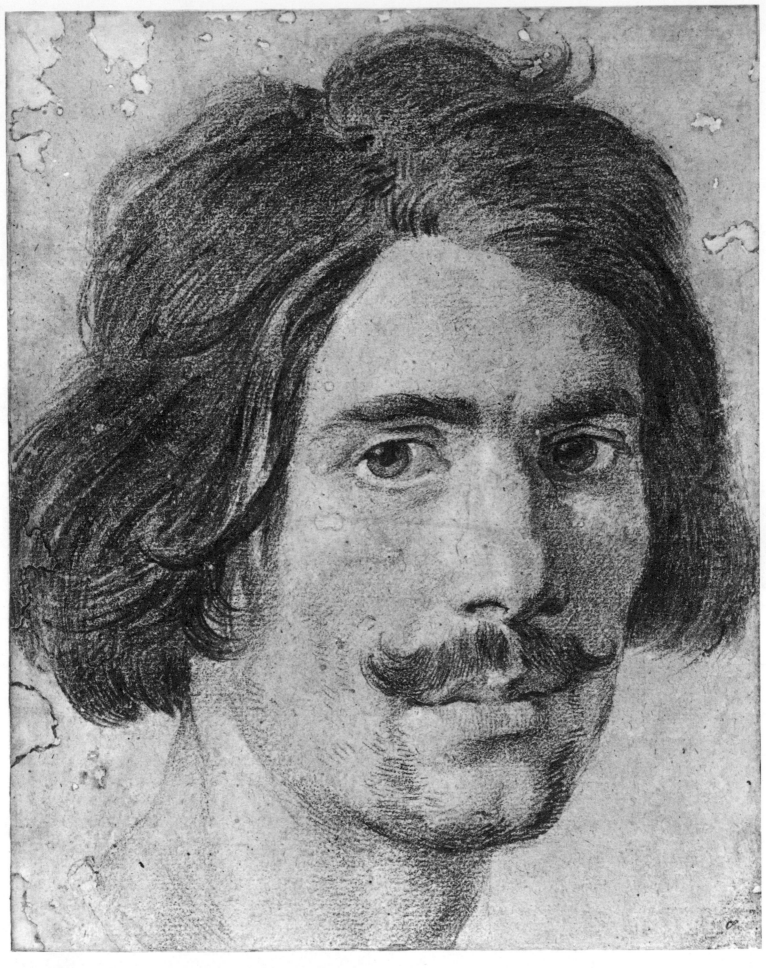

23 PORTRAIT OF A MAN WITH A MOUSTACHE, C. 1630

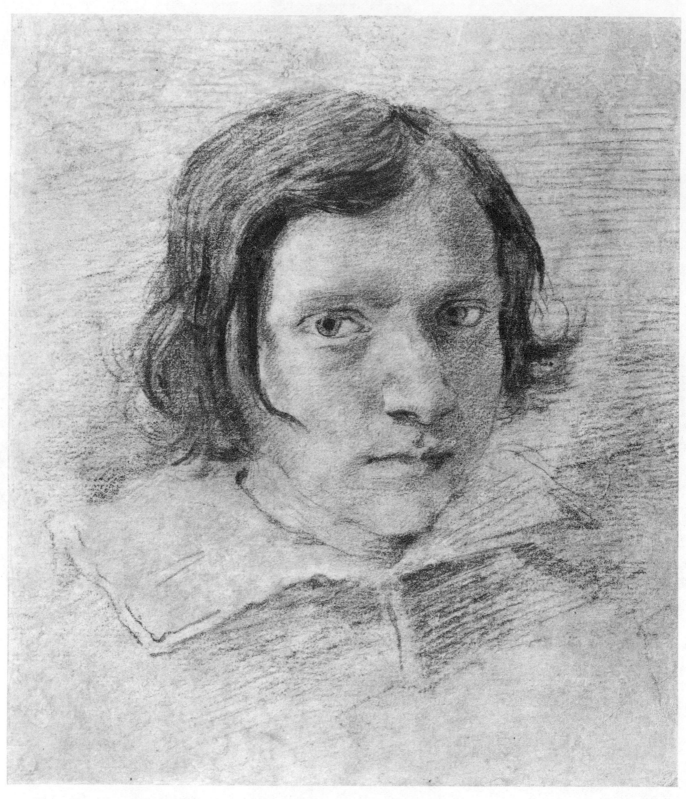

24 PORTRAIT OF A BOY, c. 1630

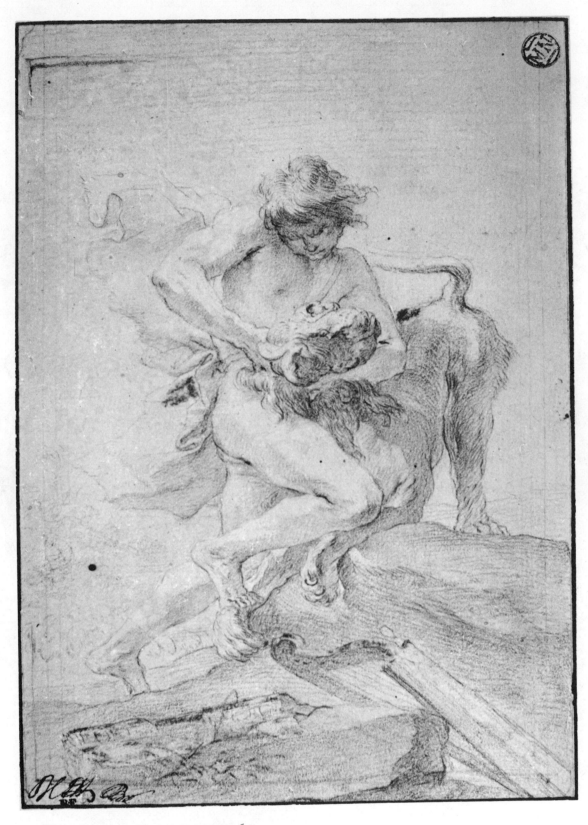

25 DAVID STRANGLING THE LION, 1631

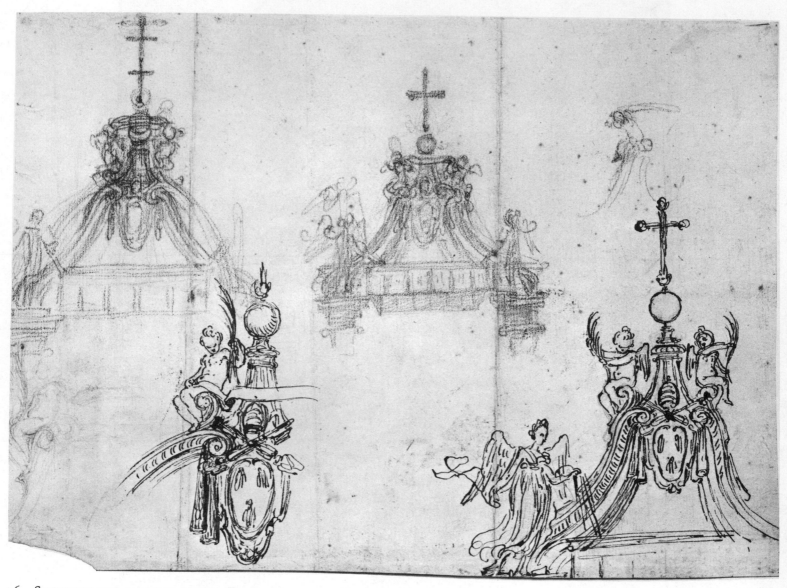

26　Sketches for the top of the Baldacchino, c. 1631

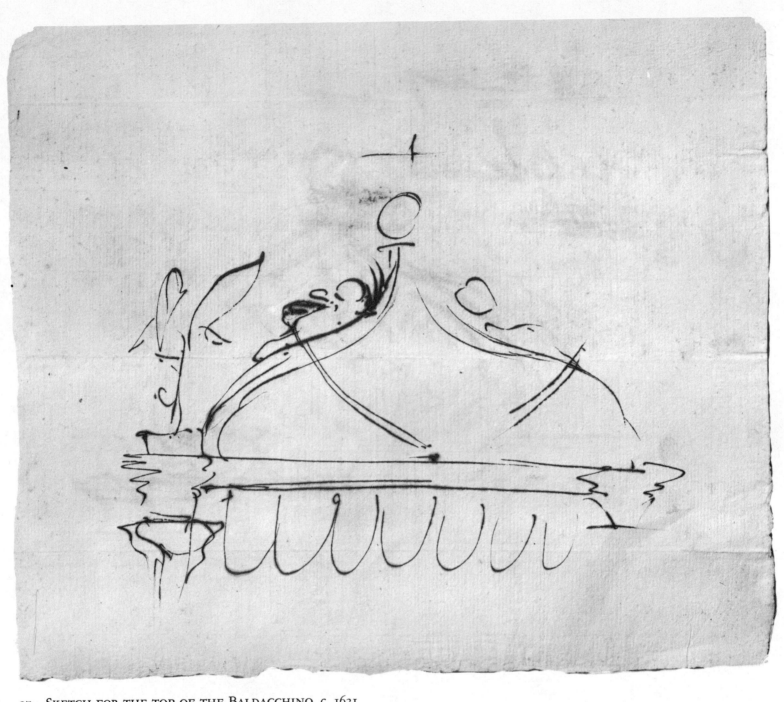

27 SKETCH FOR THE TOP OF THE BALDACCHINO, C. 1631

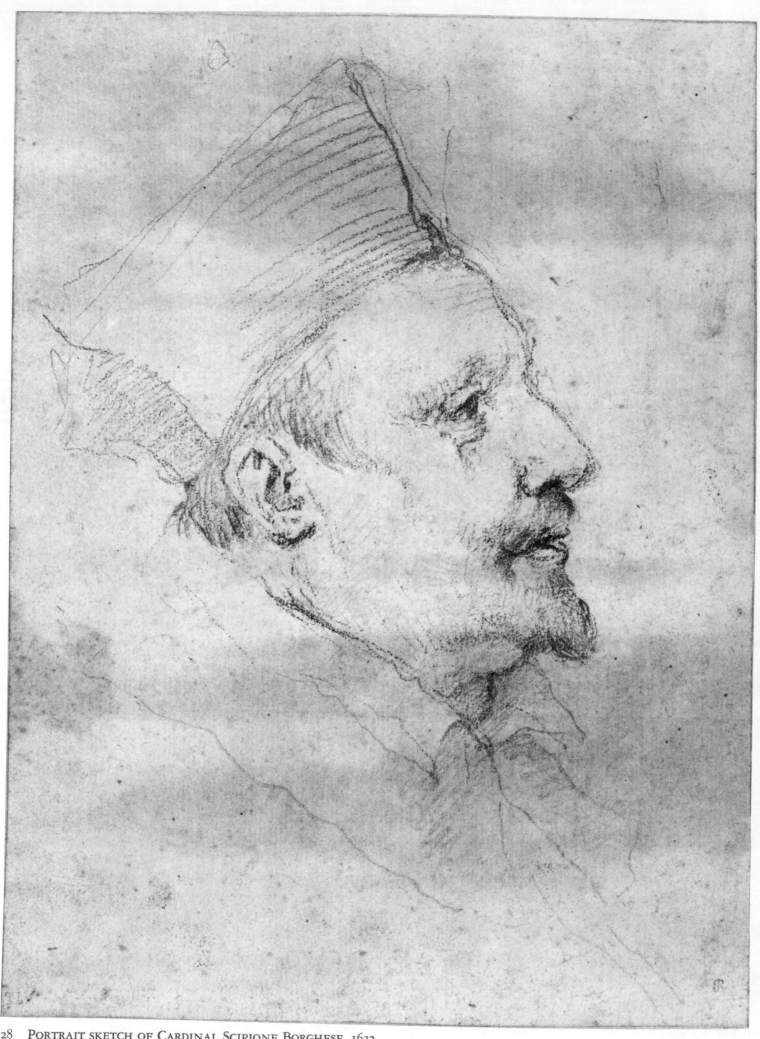

28 PORTRAIT SKETCH OF CARDINAL SCIPIONE BORGHESE, 1632

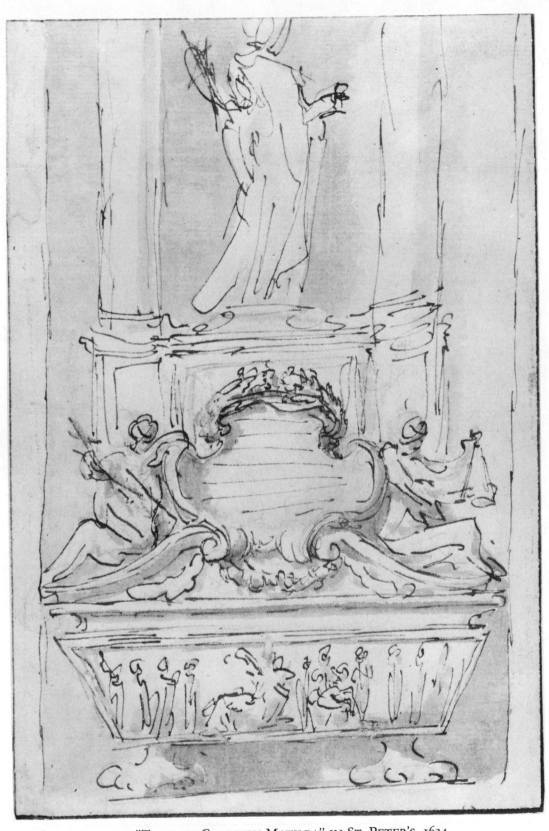

29 STUDY FOR THE "TOMB OF COUNTESS MATILDA" IN ST. PETER'S, 1634

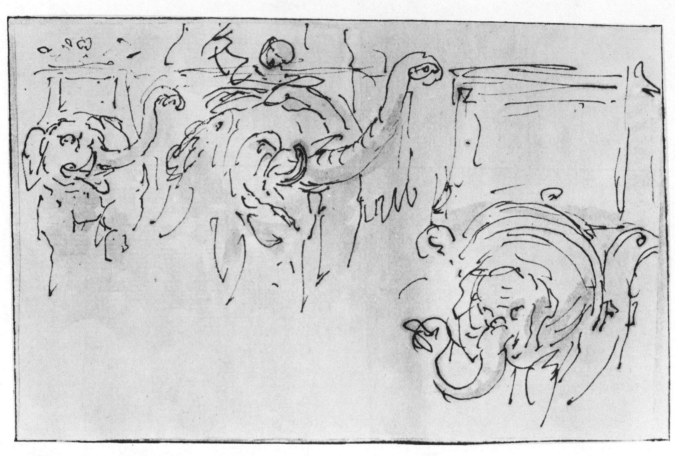

30 THREE STUDIES OF AN ELEPHANT, 1632

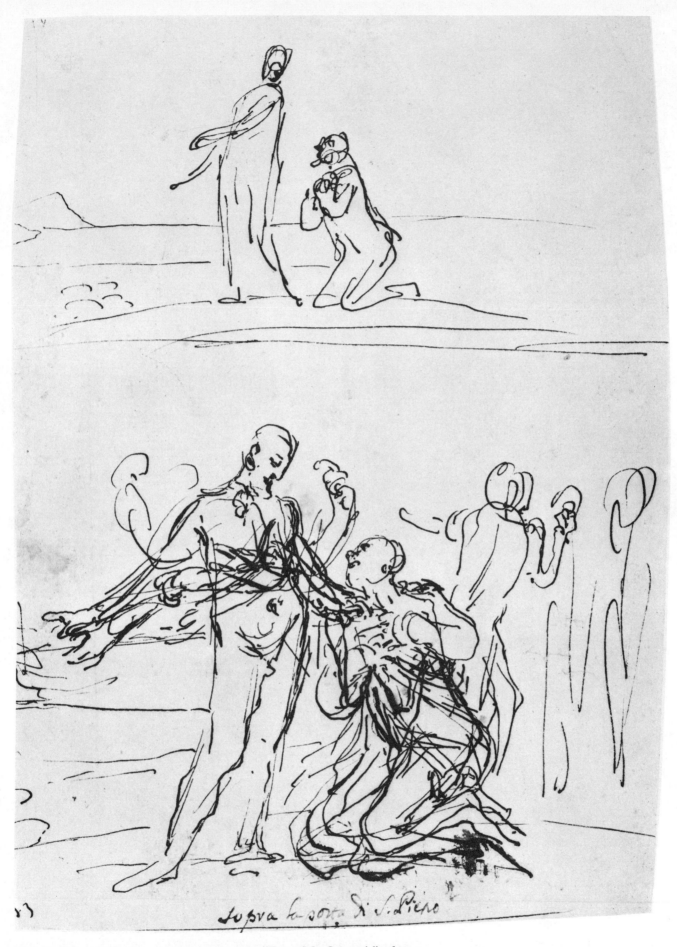

sopra la sorte di S. Piero

31 STUDIES FOR THE OVERDOOR RELIEF "FEED MY SHEEP!," 1633–4

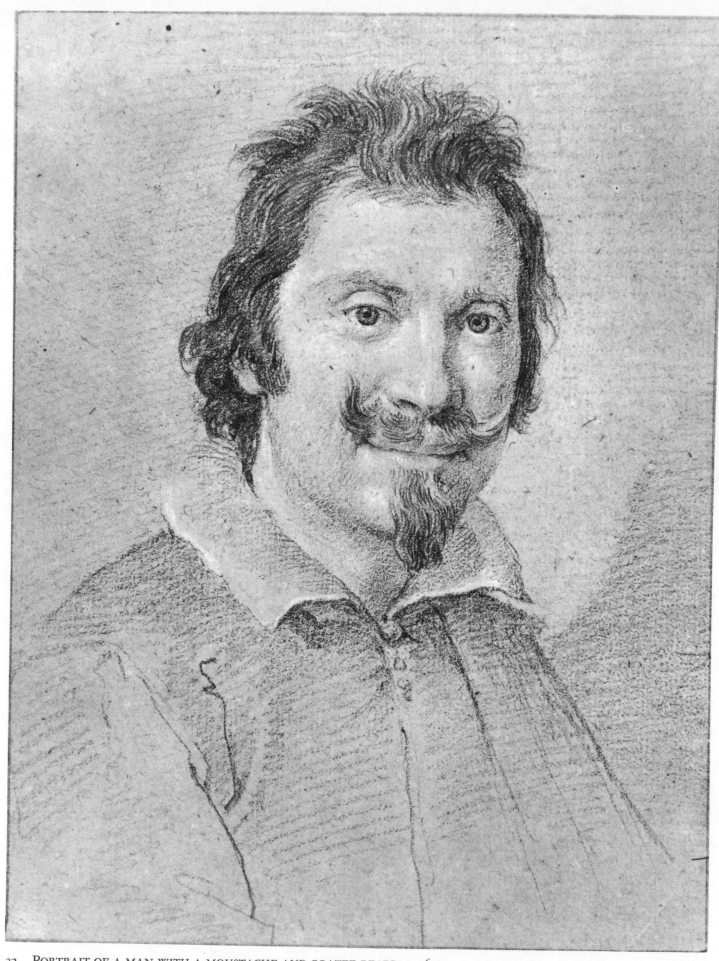

32 PORTRAIT OF A MAN WITH A MOUSTACHE AND GOATEE BEARD, C. 1635

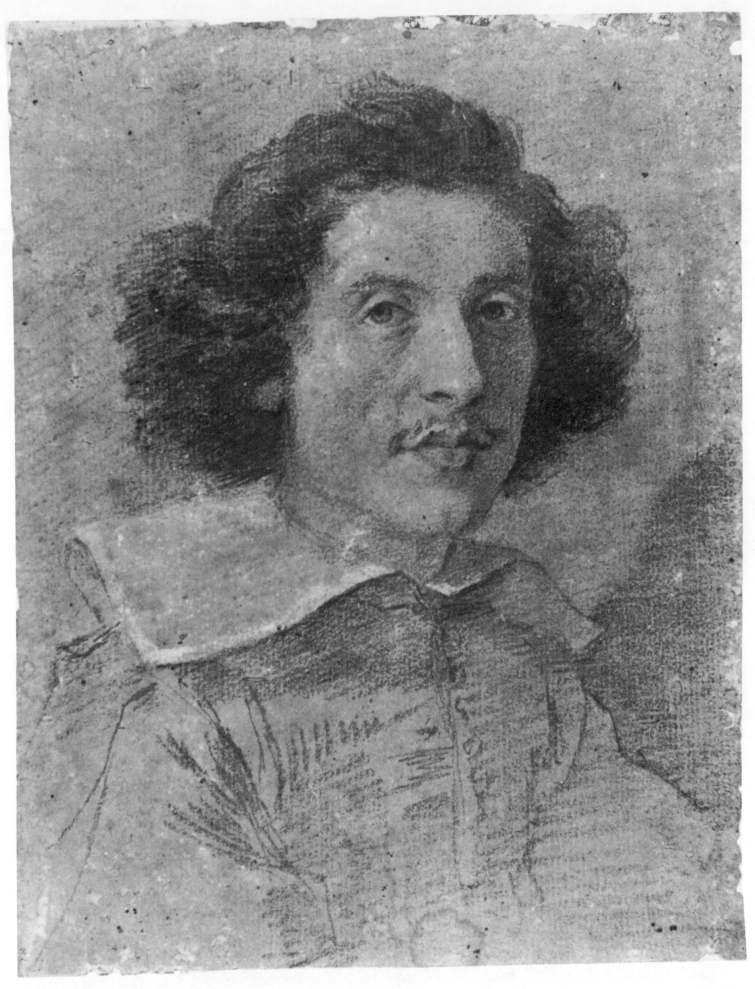

33 PORTRAIT OF A MAN, C. 1635

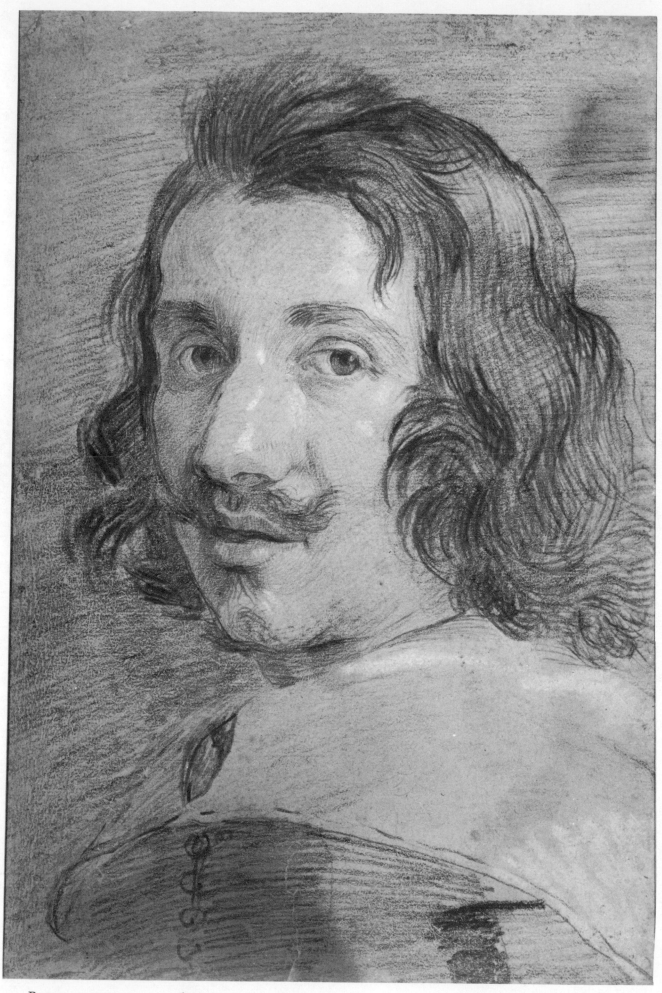

34 PORTRAIT OF A MAN, C. 1635

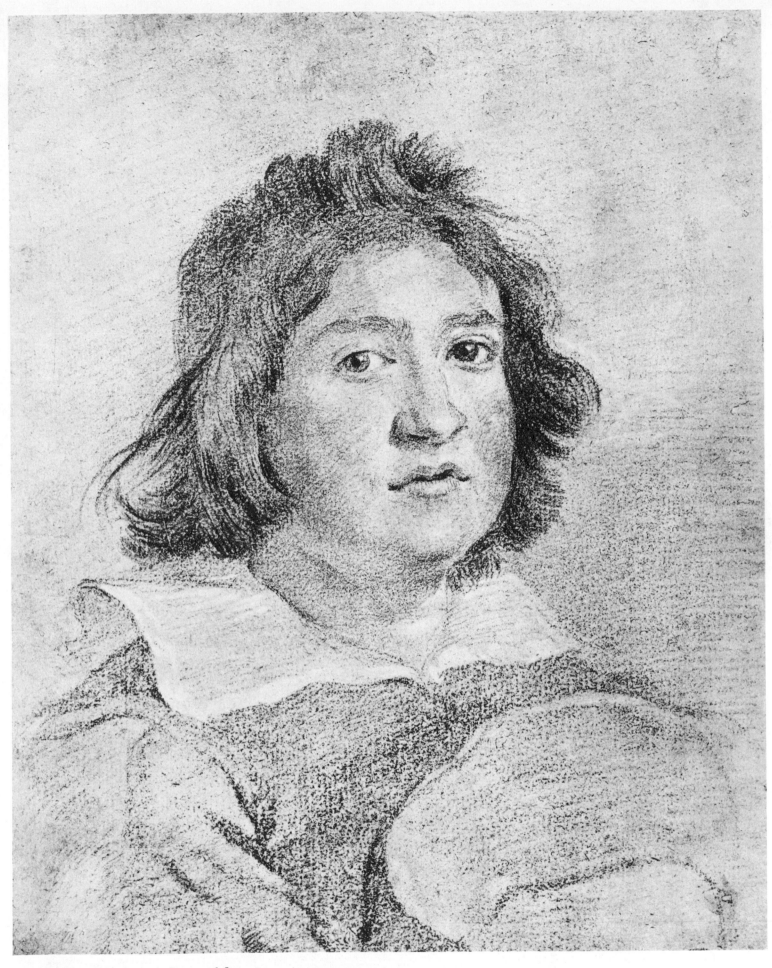

35 PORTRAIT OF SISINIO POLI, 1638

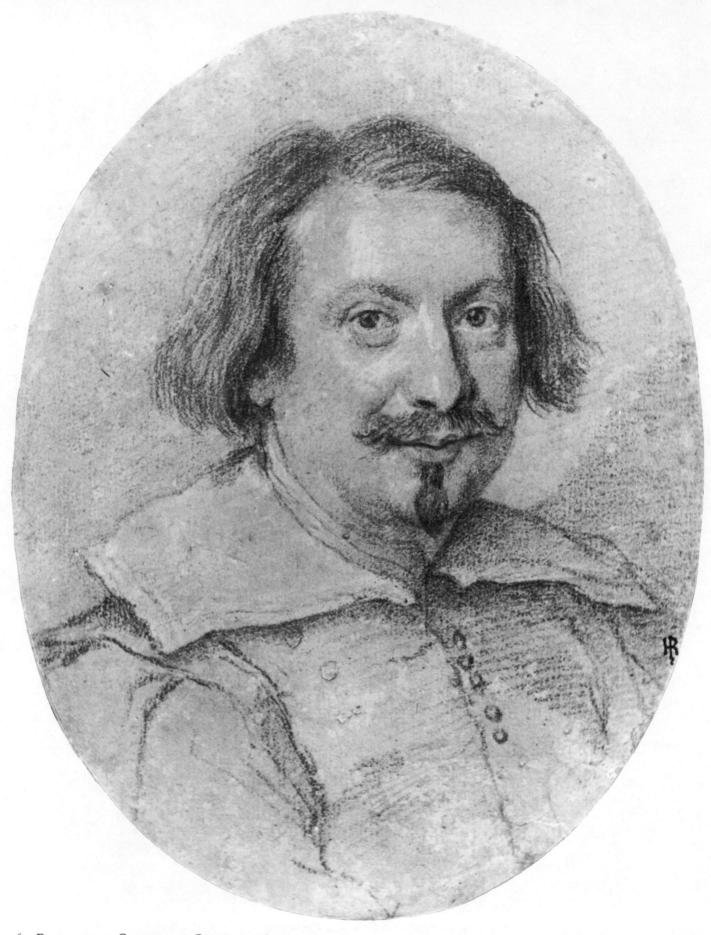

36 PORTRAIT OF OTTAVIANO CASTELLI, 1642–5

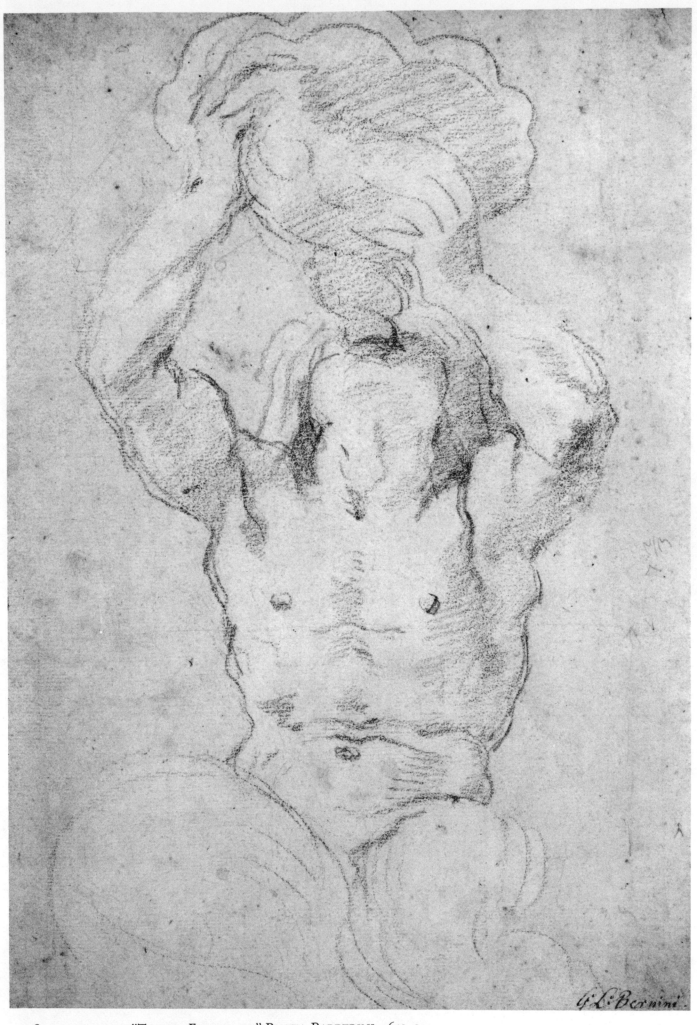

G.L. Bernini.

37 STUDY FOR THE "TRITON FOUNTAIN," PIAZZA BARBERINI, 1642–3

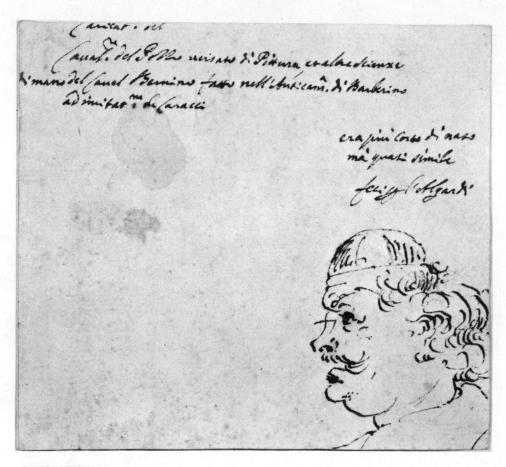

38　CARICATURE OF CASSIANO DAL POZZO, BEFORE 1644

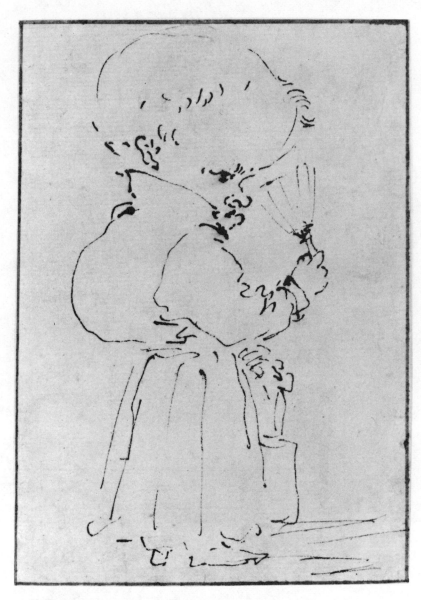

39 CARICATURE OF A PRIEST WITH A WINEGLASS
AND MONEY BAG (?), 1640–5

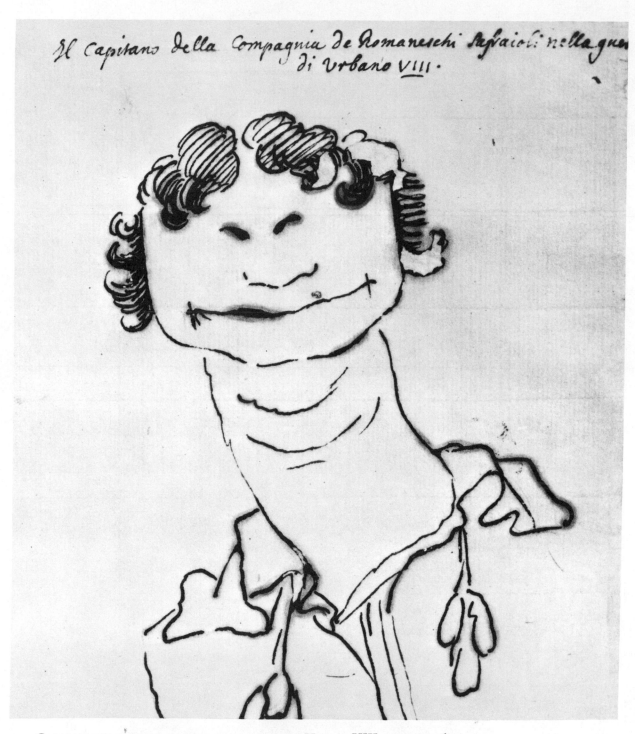

40 CARICATURE OF A CAPTAIN IN THE ARMY OF URBAN VIII, BEFORE 1644

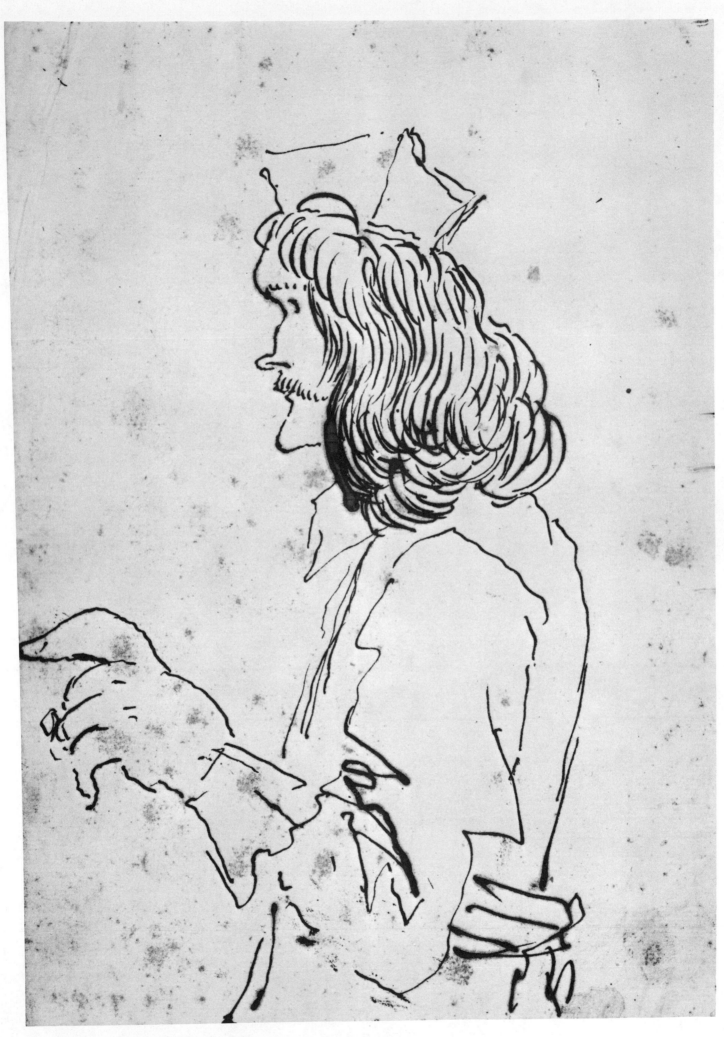

41 Caricature of a cleric, c. 1640–5

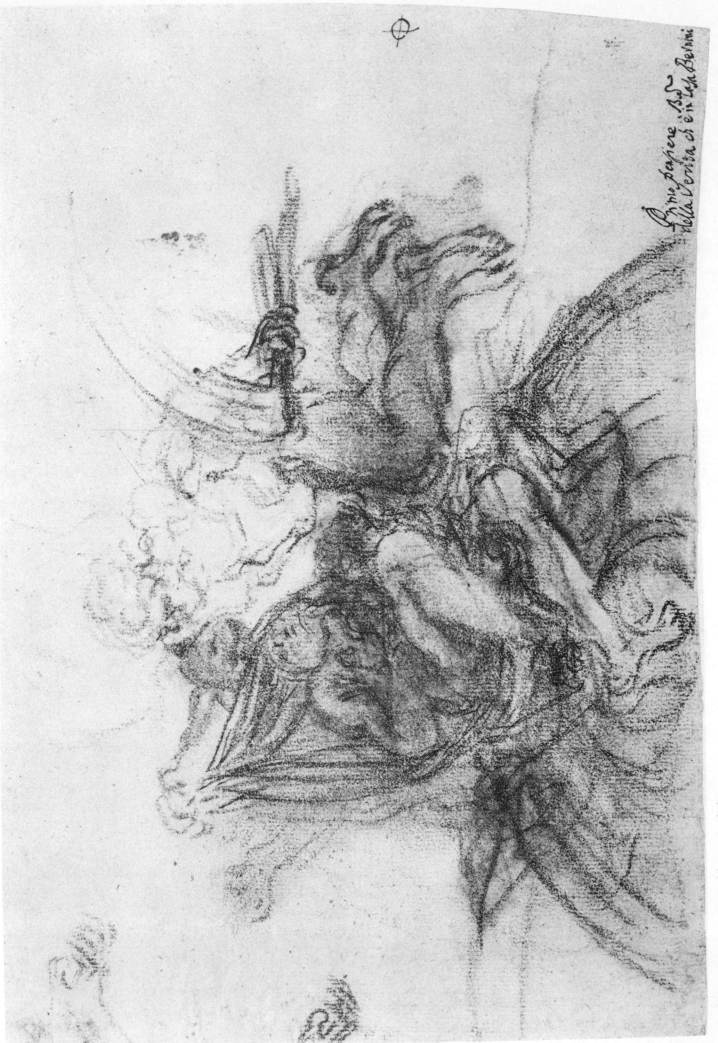

42 TRUTH UNVEILED BY TIME, c. 1646

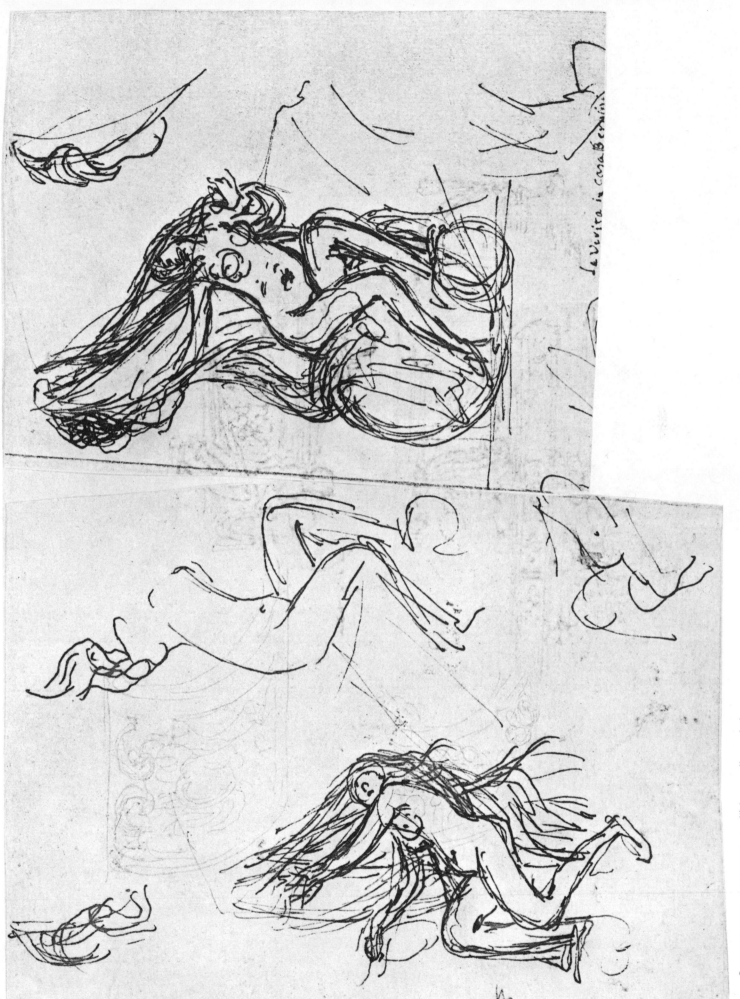

La Verità in Casa Bernini

43 STUDIES FOR A STATUE OF "TRUTH," C. 1646

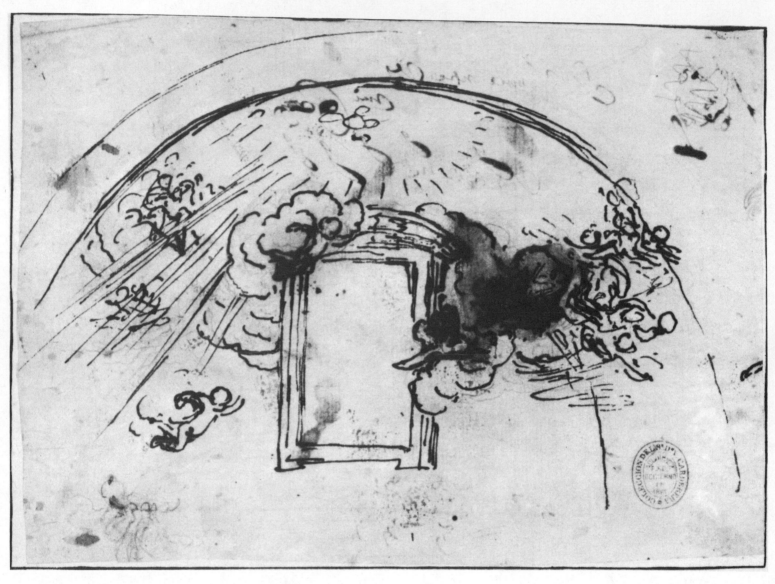

44 STUDY FOR THE DECORATION OF THE VAULT OF THE CORNARO CHAPEL, S. MARIA DELLA
VITTORIA, BY 1647

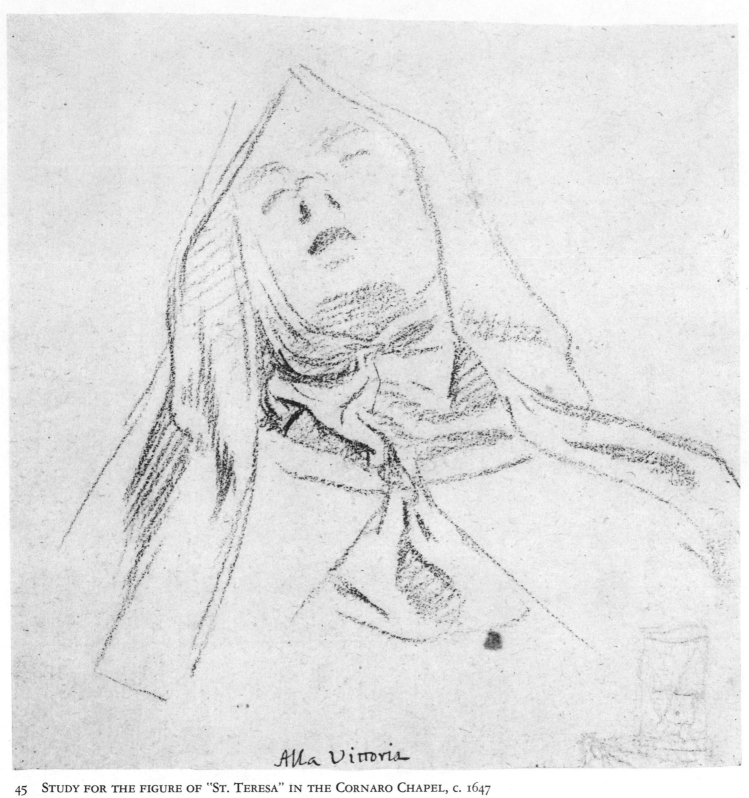

Alla Vittoria

45 STUDY FOR THE FIGURE OF "ST. TERESA" IN THE CORNARO CHAPEL, C. 1647

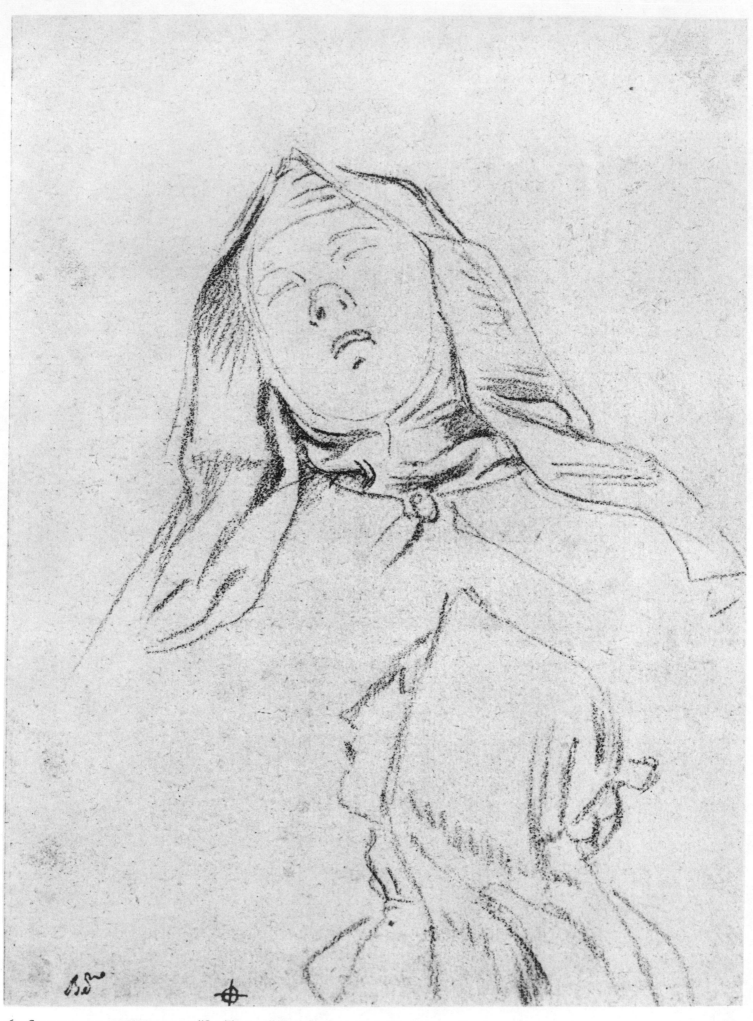

46 Studies for the figure of "St. Teresa" in the Cornaro Chapel, c. 1647

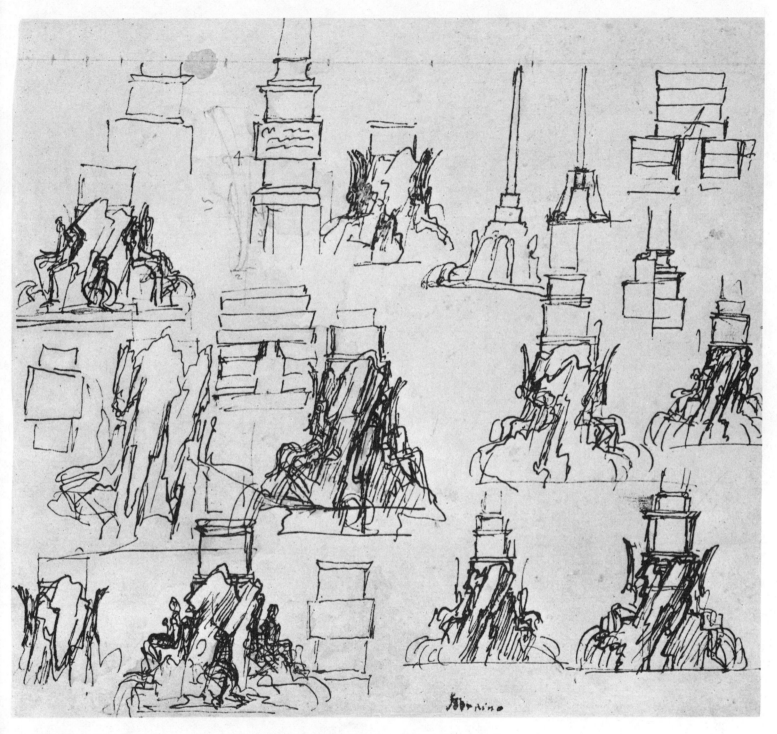

47 STUDIES FOR THE "FOUNTAIN OF THE FOUR RIVERS," PIAZZA NAVONA, c. 1648

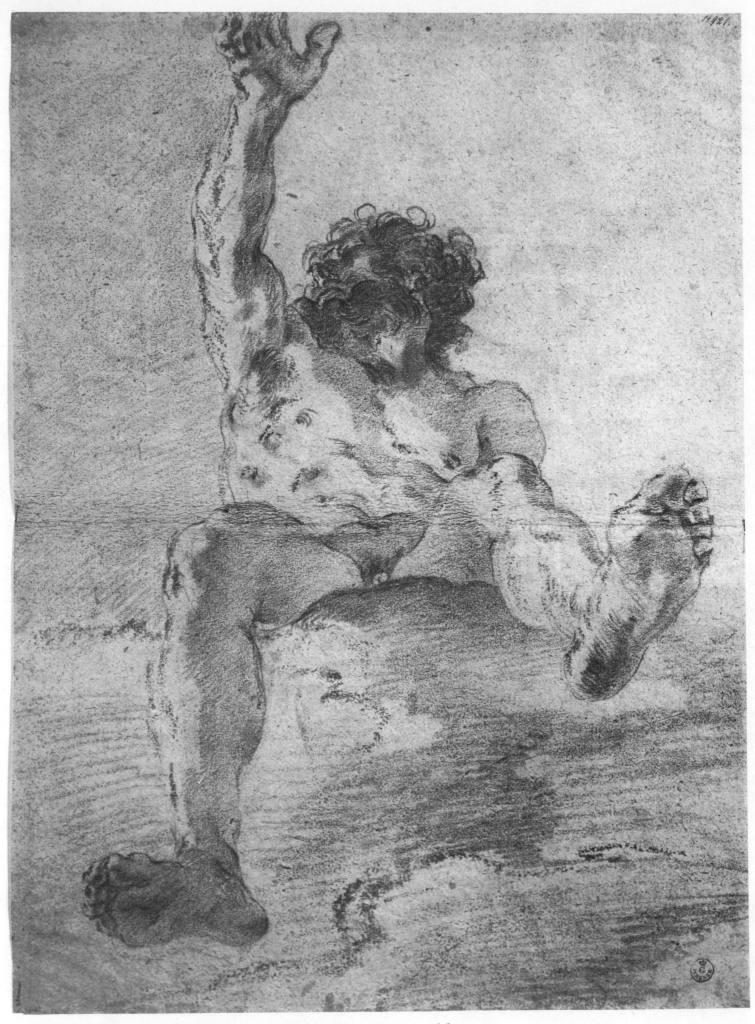

48 ACADEMY STUDY OF A SEATED MALE NUDE SEEN FROM BELOW, C. 1648

OSSA

CAROLI·CARDINALIS·PII

49 DESIGN FOR THE "TOMB SLAB OF CARDINAL CARLO EMMANUELE PIO," 1649–50

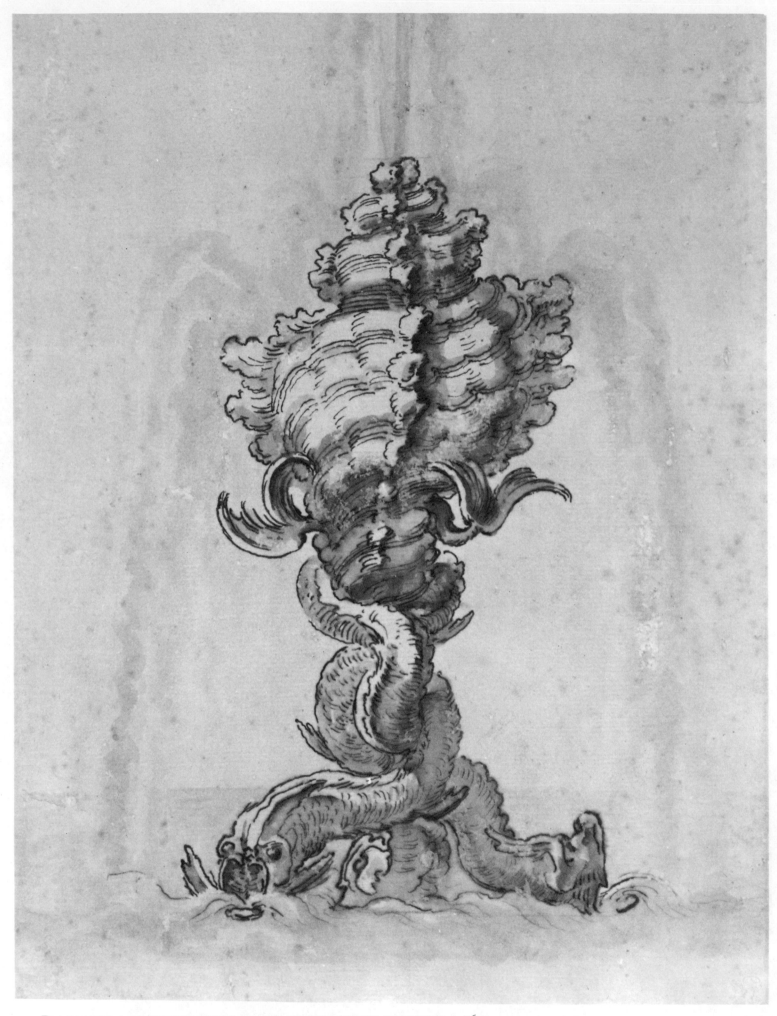

50 DESIGN FOR A FOUNTAIN USING A SHELL SUPPORTED BY DOLPHINS, C. 1652

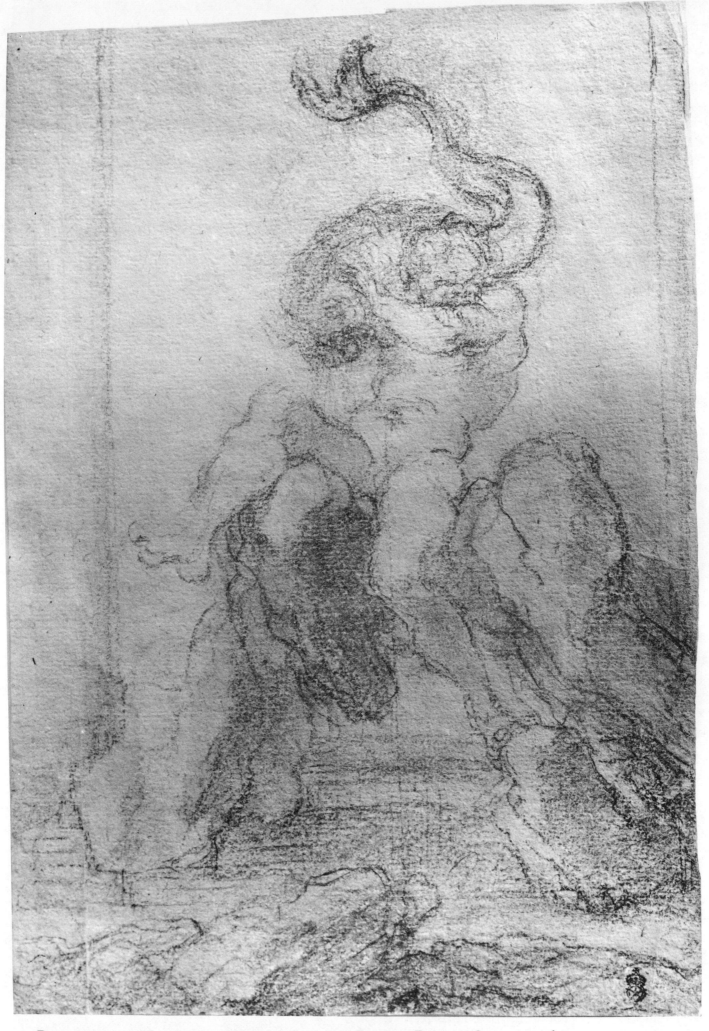

51 DESIGN FOR THE "FOUNTAIN OF NEPTUNE" AT THE PALAZZO ESTENSE, SASSUOLO, 1652

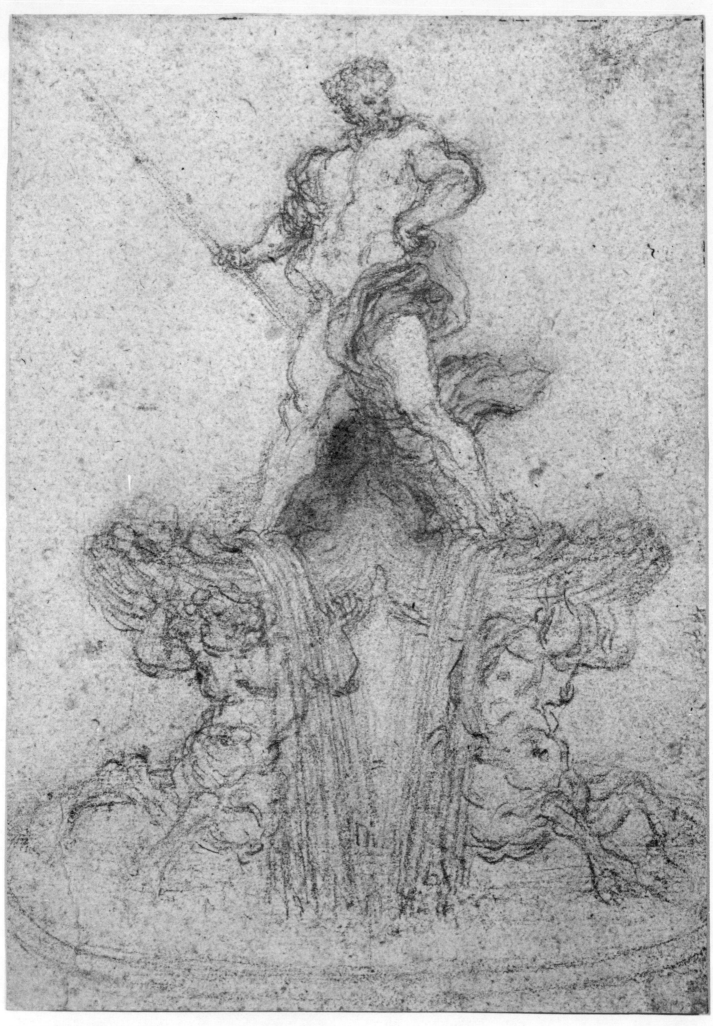

52 DESIGN FOR THE "FOUNTAIN OF NEPTUNE," SASSUOLO, 1652

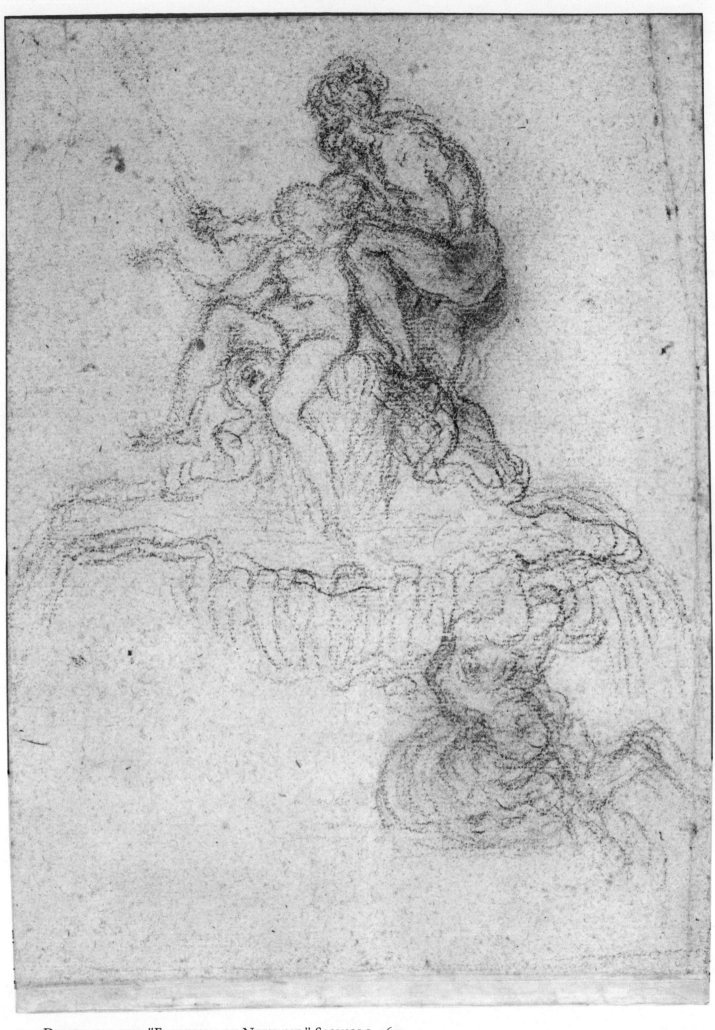

53 Design for the "Fountain of Neptune," Sassuolo, 1652

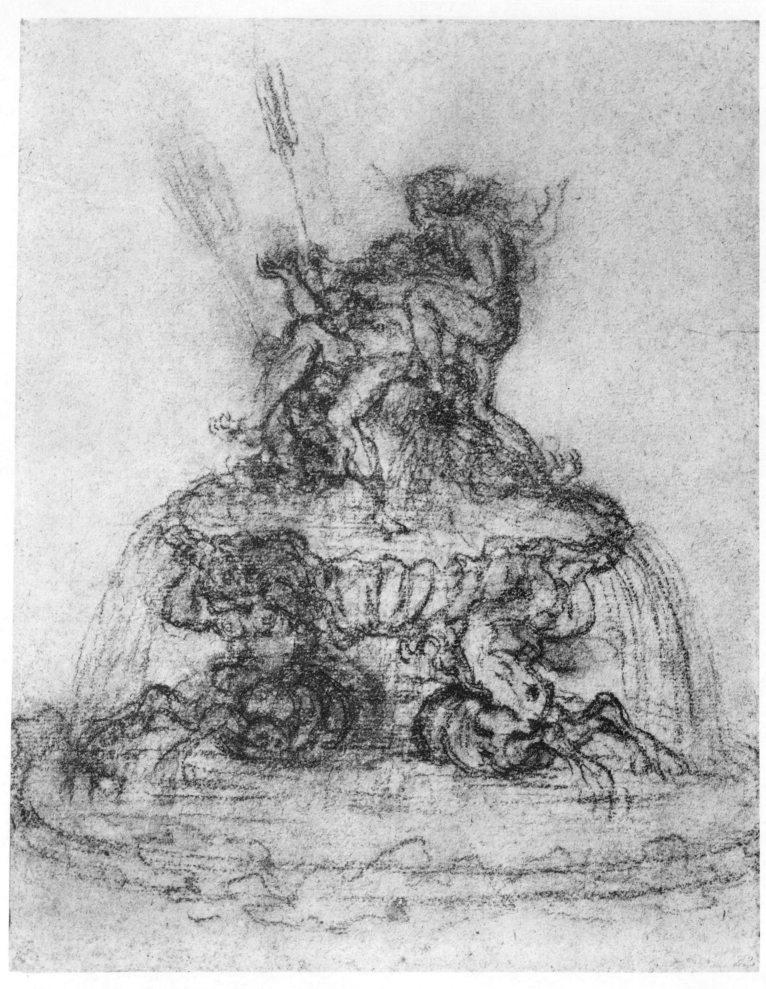

54 DESIGN FOR THE "FOUNTAIN OF NEPTUNE," SASSUOLO, 1652

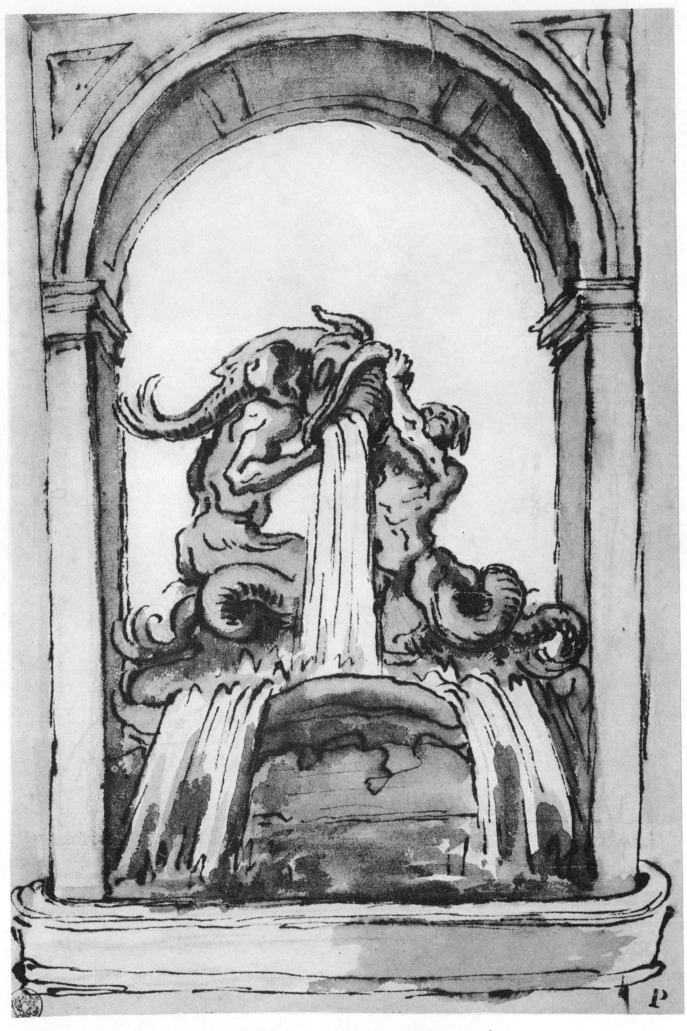

55 DESIGN FOR A FOUNTAIN WITH TWO TRITONS SUPPORTING A DOLPHIN, c. 1652

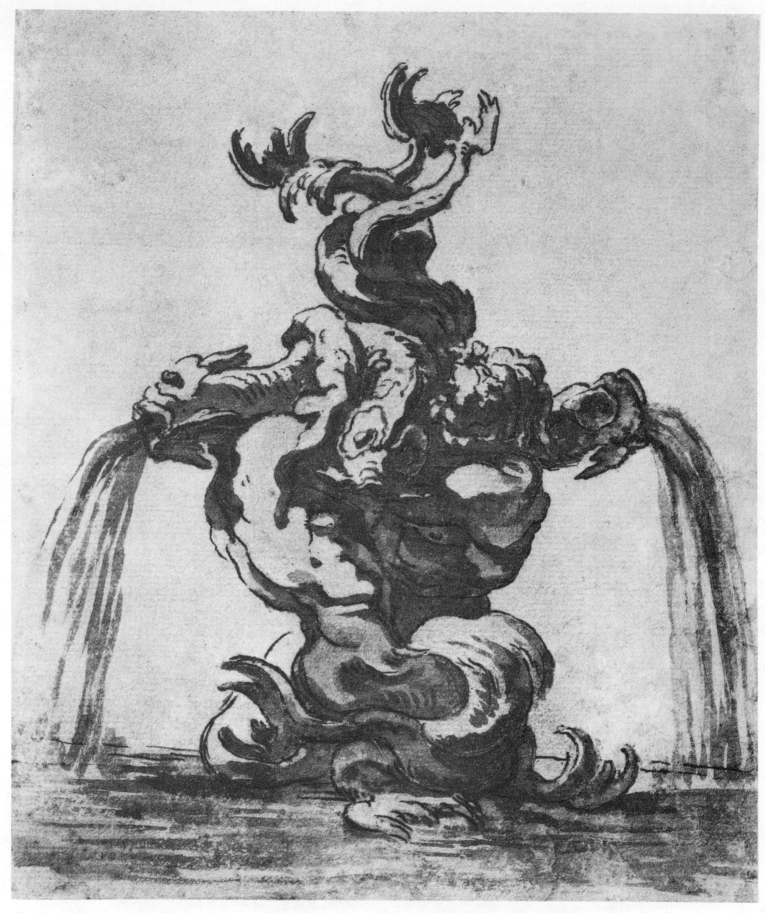

56 Design for a fountain with Tritons supporting dolphins, 1652–3

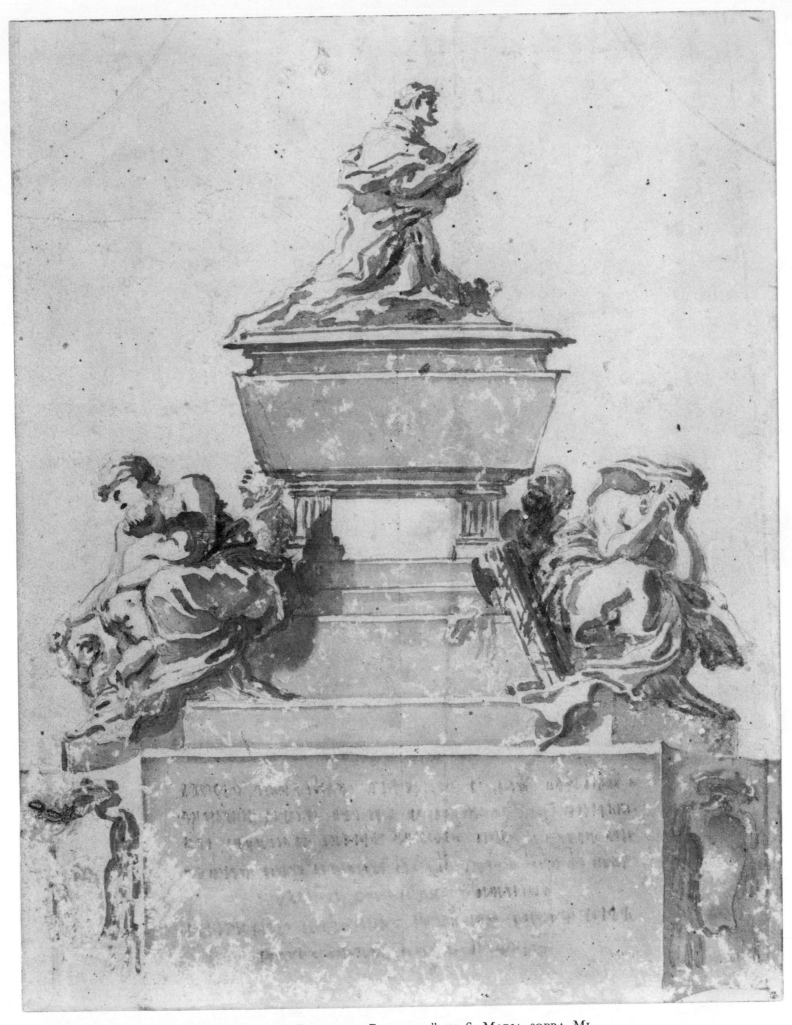

57 DESIGN FOR THE "TOMB OF CARDINAL DOMENICO PIMENTEL" IN S. MARIA SOPRA MI-
NERVA, 1653

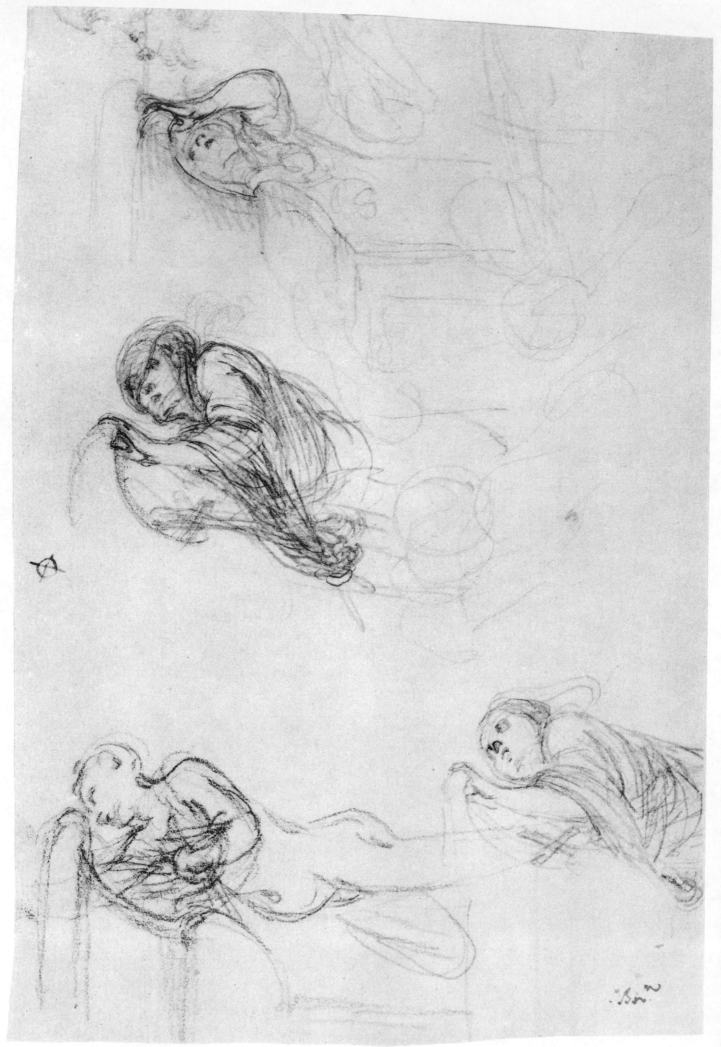

58 Studies for the figure of Faith on the "Pimentel Tomb," 1653

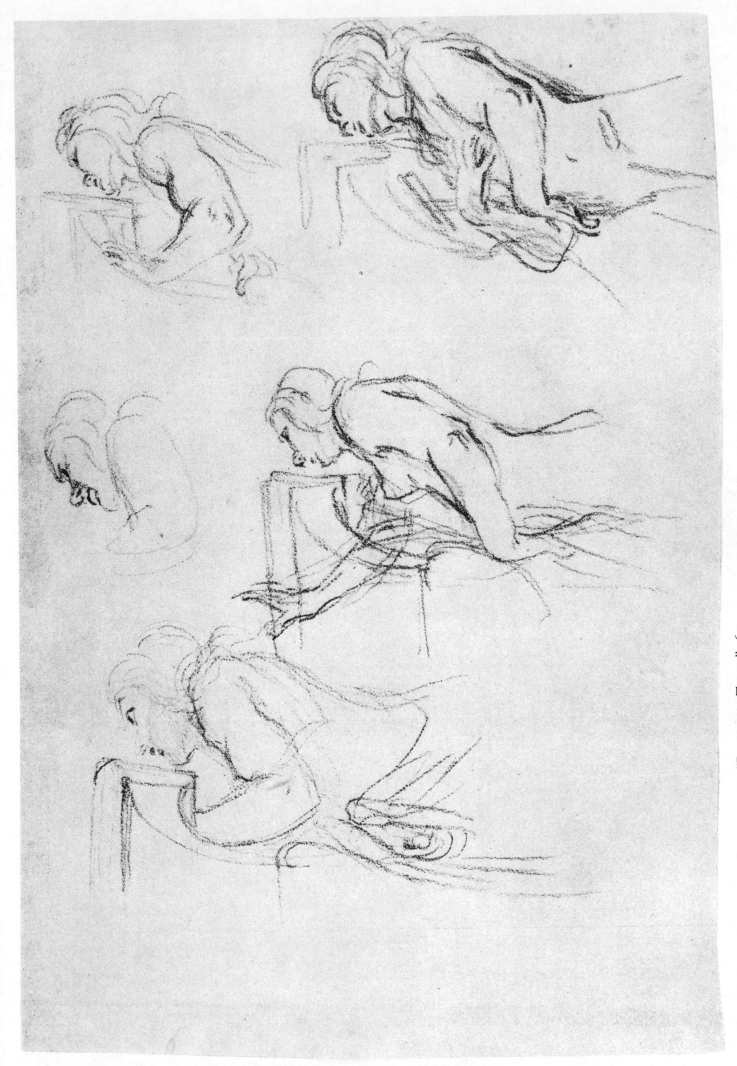

STUDIES FOR THE FIGURE OF FAITH ON THE "PIMENTEL TOMB," 1653

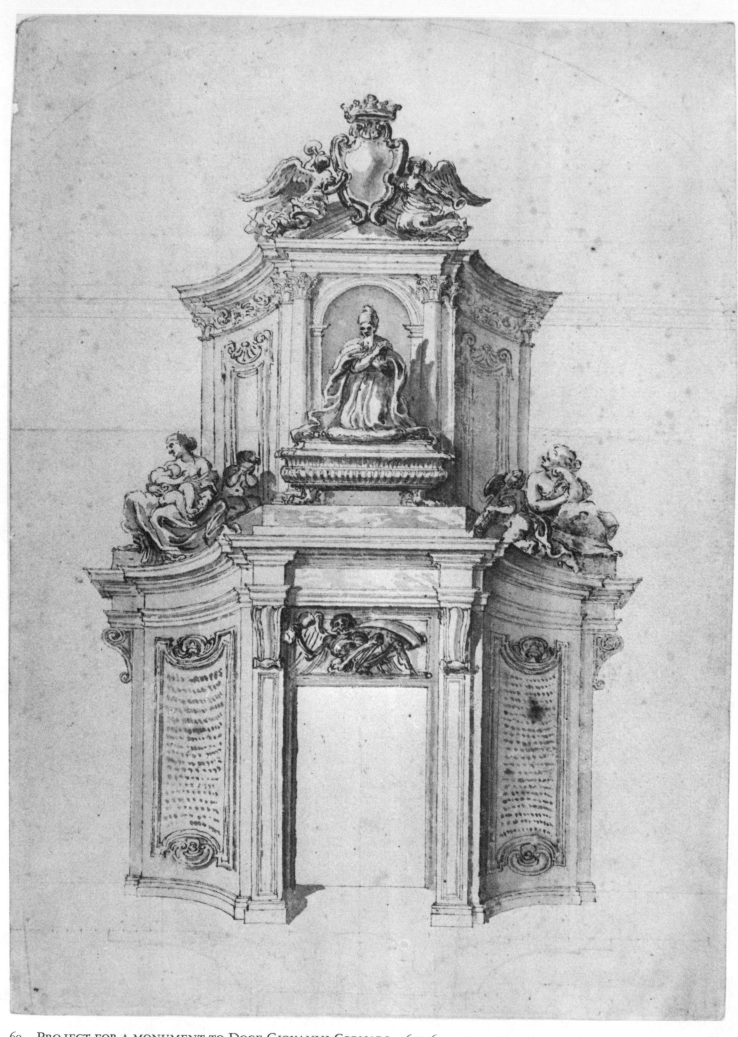

60 PROJECT FOR A MONUMENT TO DOGE GIOVANNI CORNARO, 1653–6

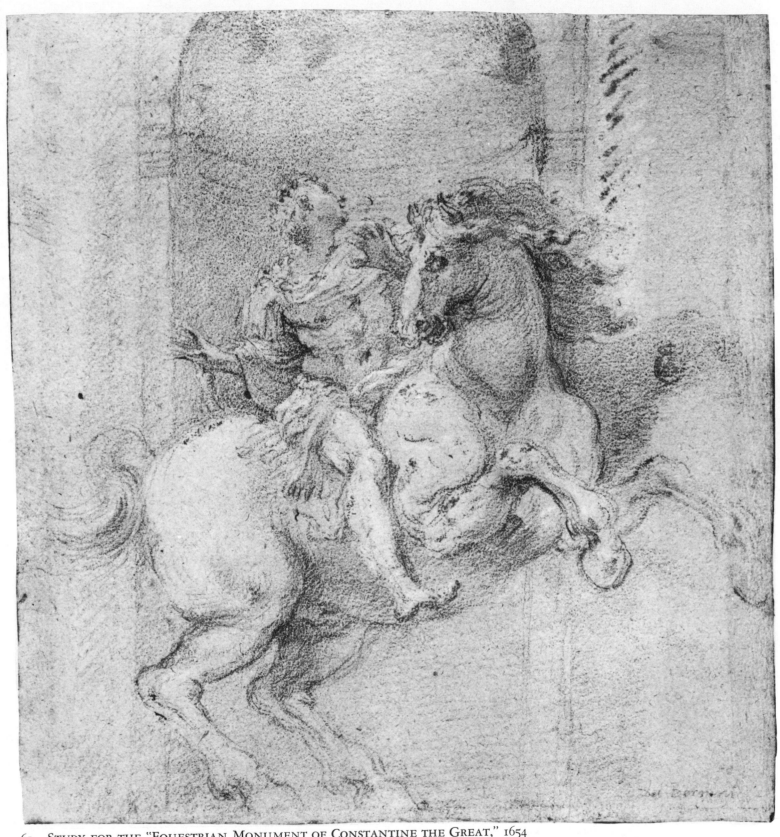

61 STUDY FOR THE "EQUESTRIAN MONUMENT OF CONSTANTINE THE GREAT," 1654

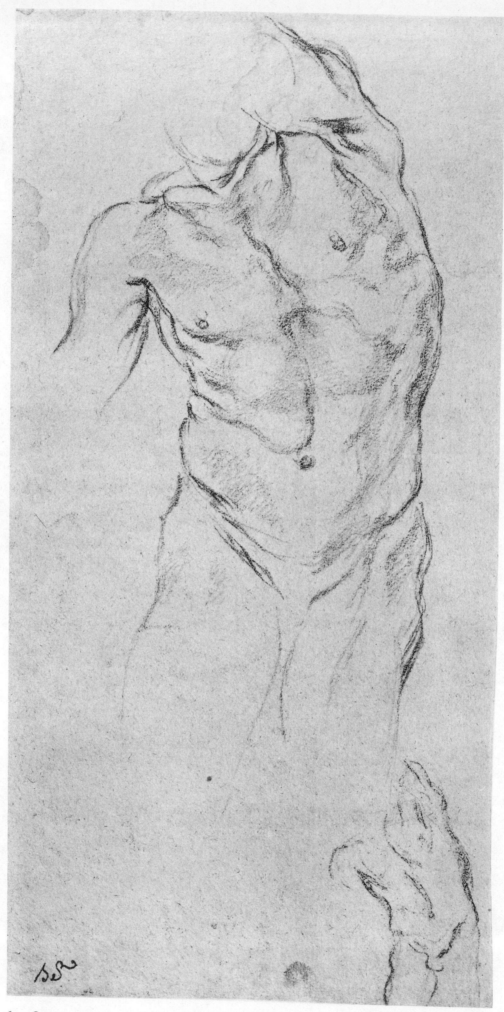

62 STUDY FOR THE TORSO OF "DANIEL" IN THE CHIGI CHAPEL, S. MARIA DEL POPOLO, 1655

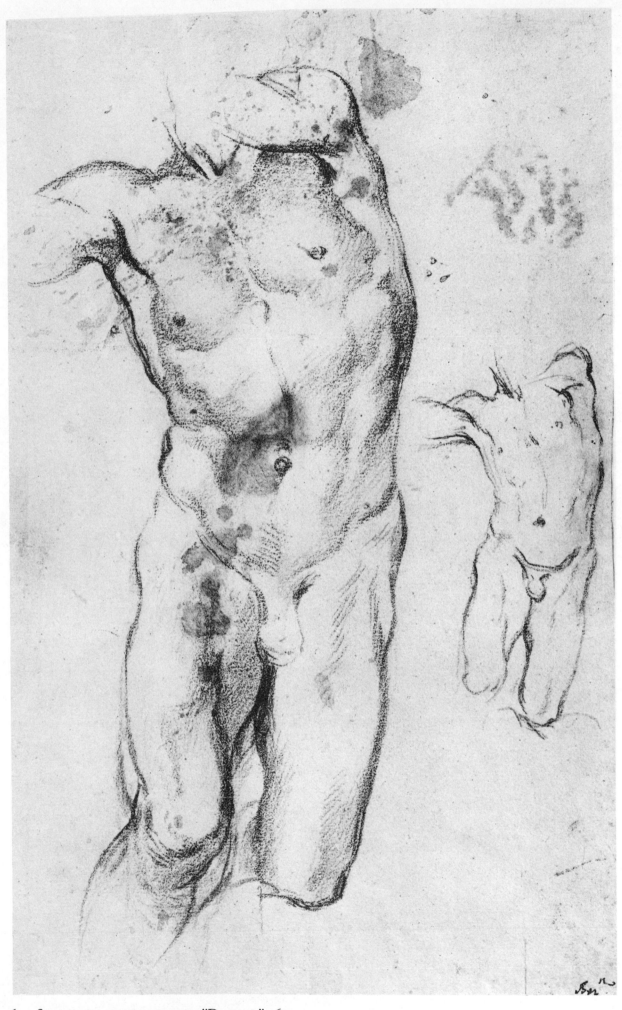

63 STUDY FOR THE FIGURE OF "DANIEL," 1655

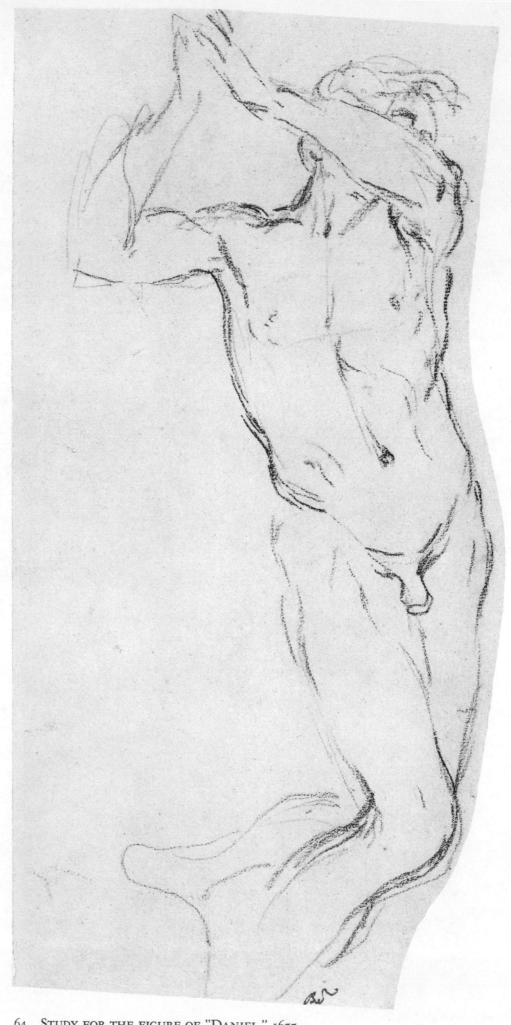

64 STUDY FOR THE FIGURE OF "DANIEL," 1655

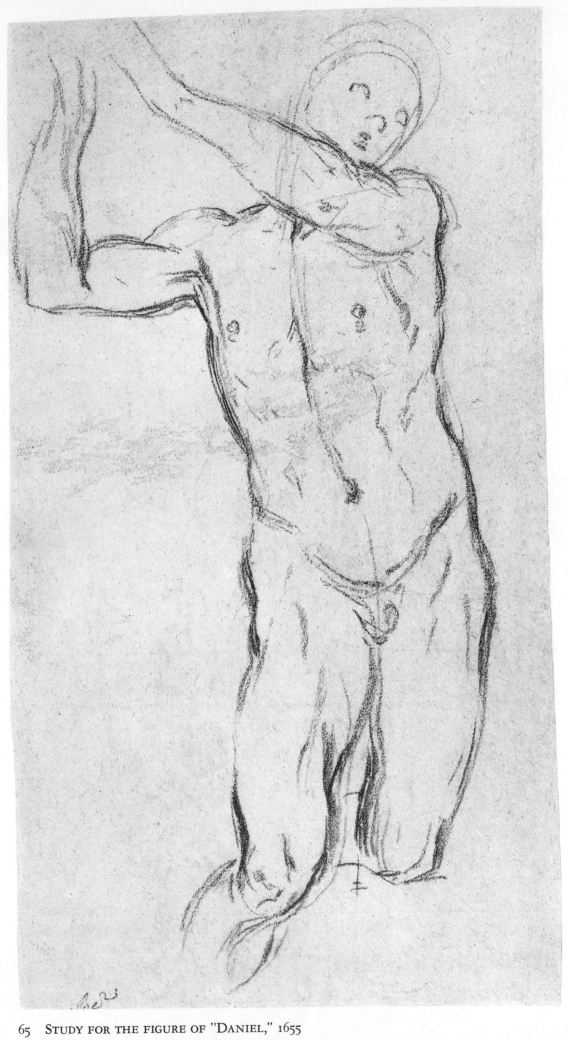

65 STUDY FOR THE FIGURE OF "DANIEL," 1655

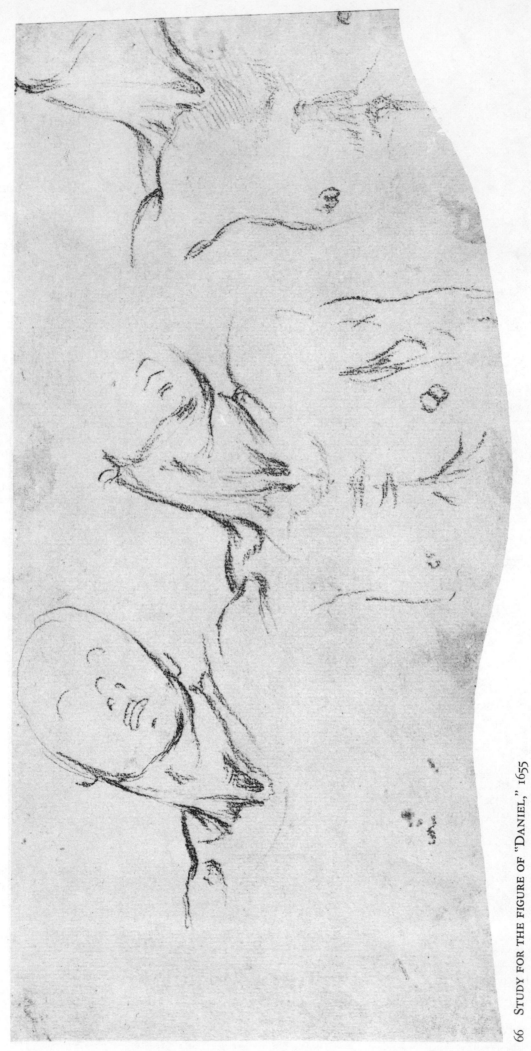

66 STUDY FOR THE FIGURE OF "DANIEL," 1655

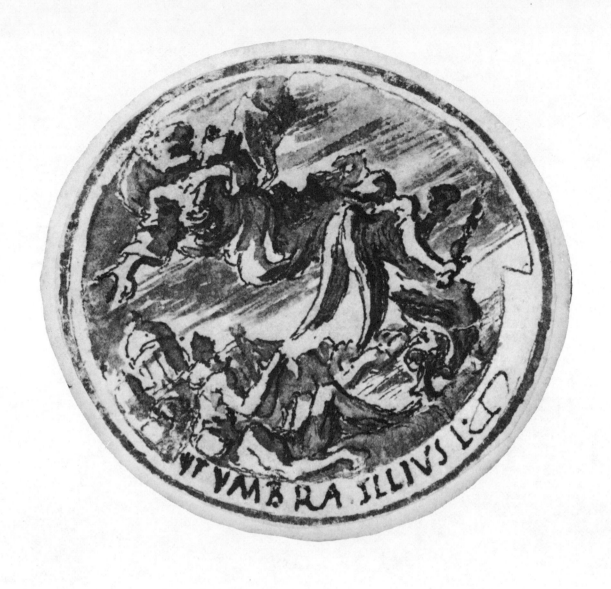

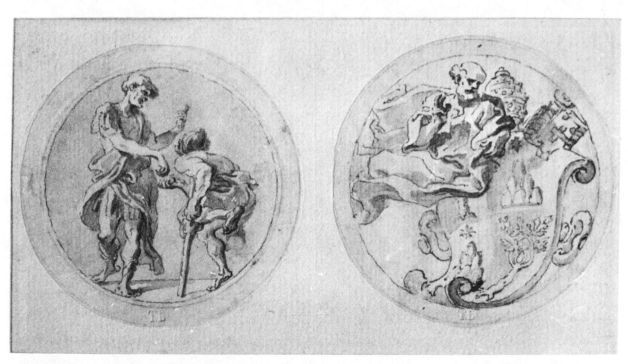

67 DESIGN FOR THE REVERSE SIDE OF THE "ANNUAL MEDAL" OF 1657; AND STUDIES FOR THE
REVERSE AND OBVERSE OF THE SILVER SCUDO ISSUED FOR THE CANONIZATION OF ST.
THOMAS OF VILLANOVA, 1658

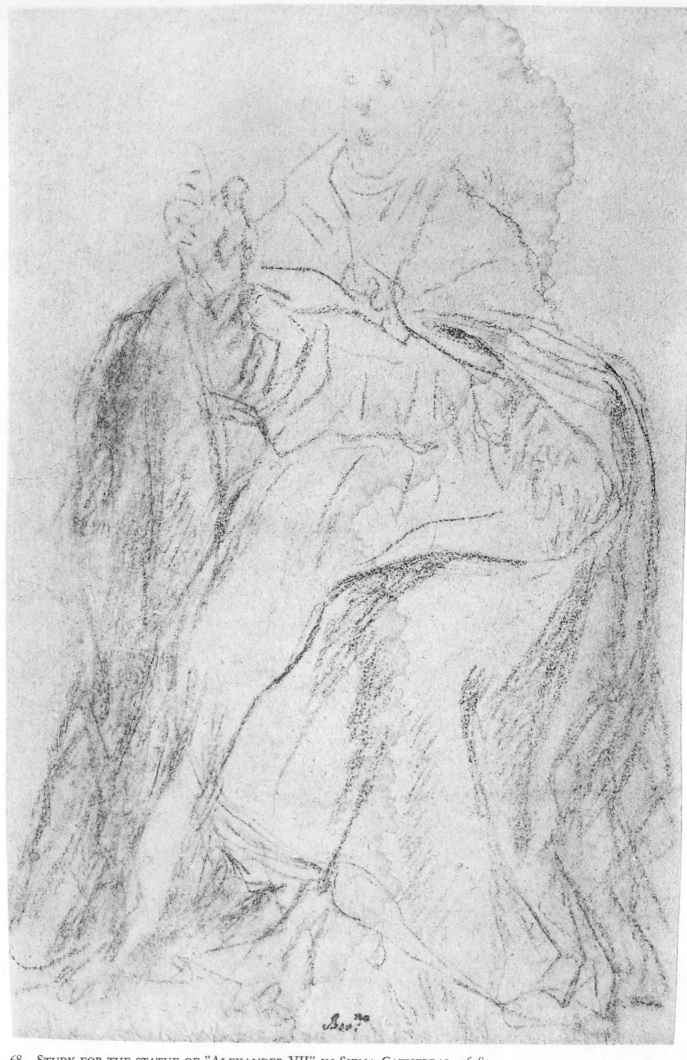

68 Study for the statue of "Alexander VII" in Siena Cathedral, 1658

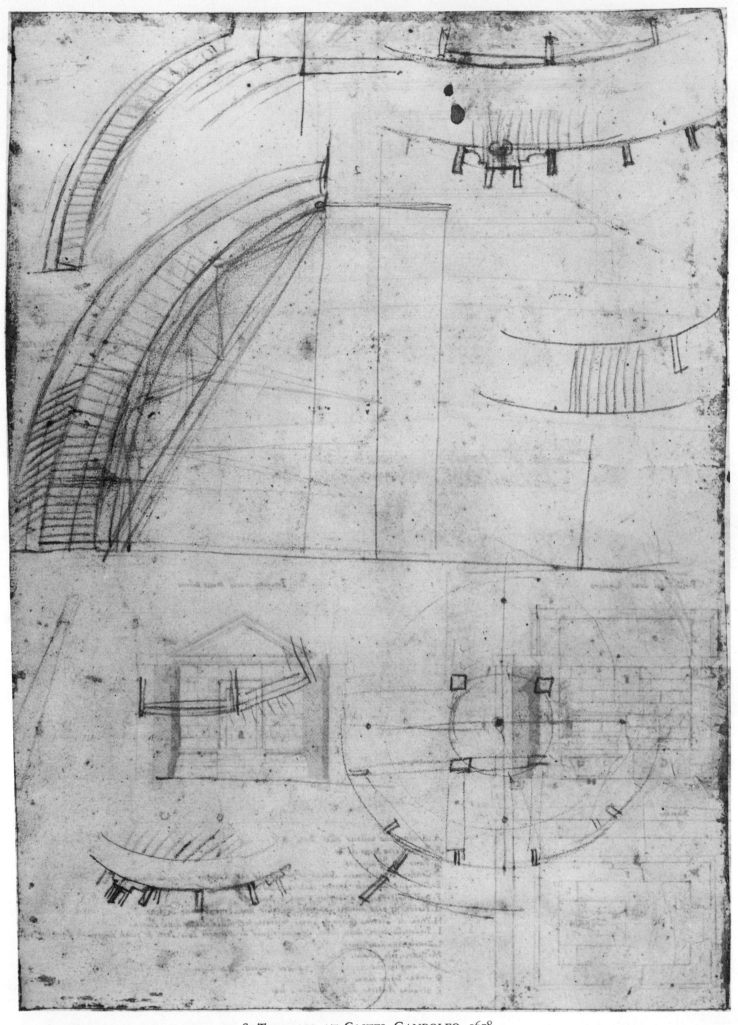

69 SKETCHES FOR THE CUPOLA OF S. TOMMASO AT CASTEL GANDOLFO, 1658

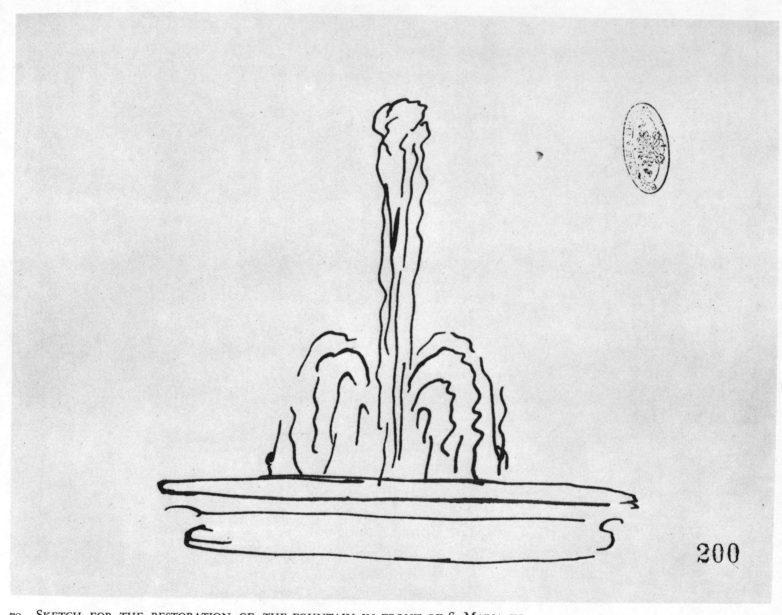

70 Sketch for the restoration of the fountain in front of S. Maria in Trastevere, 1658–9

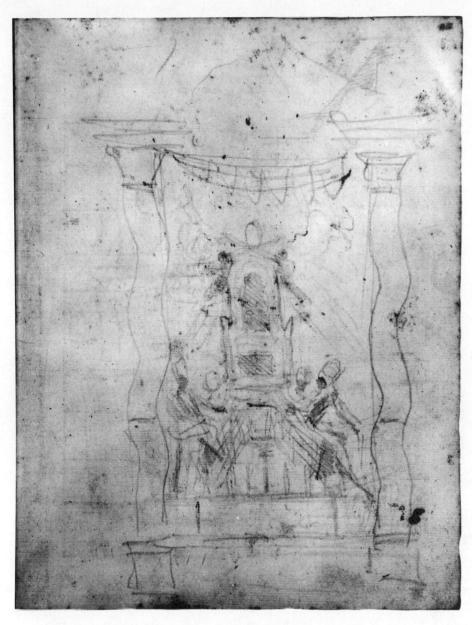

71　Sketch of the "Cathedra Petri" seen through
the Baldacchino, c. 1657

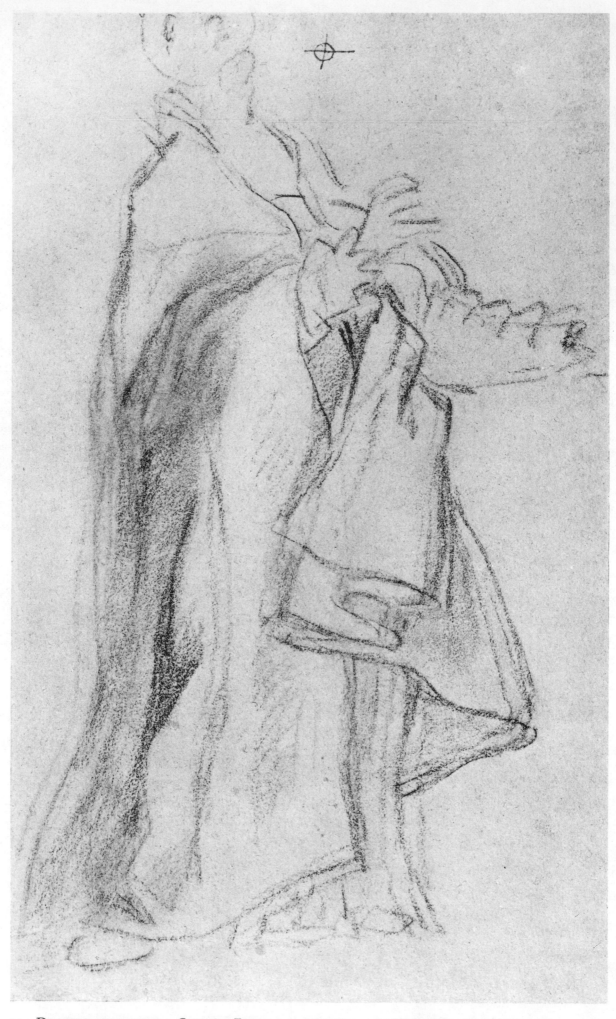

72 Drapery study for a Church Father supporting the "Cathedra Petri," c. 1660

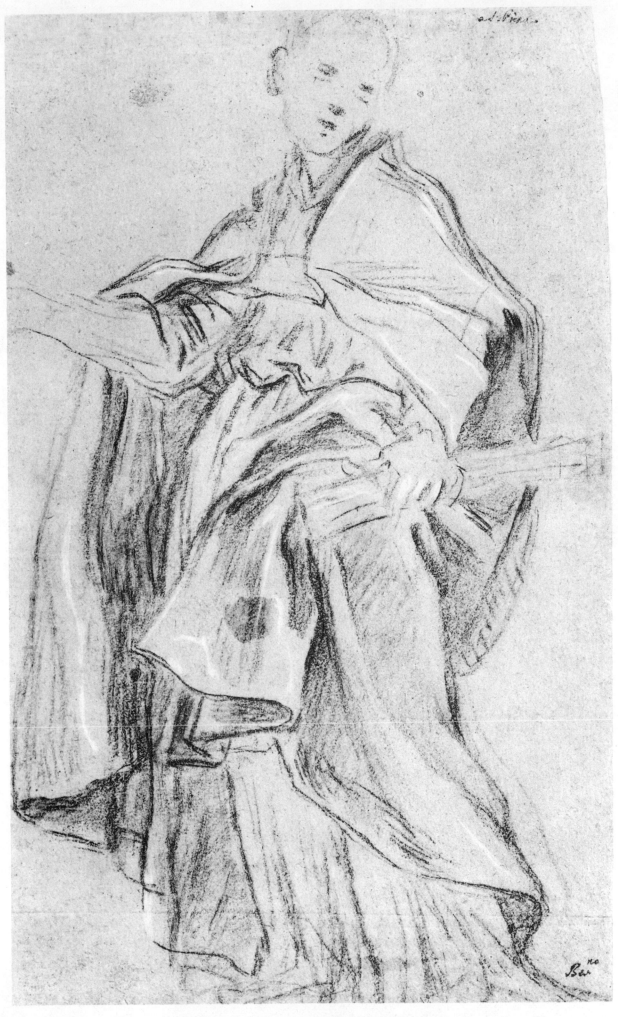

73　DRAPERY STUDY FOR A CHURCH FATHER SUPPORTING THE "CATHEDRA PETRI," c. 1660

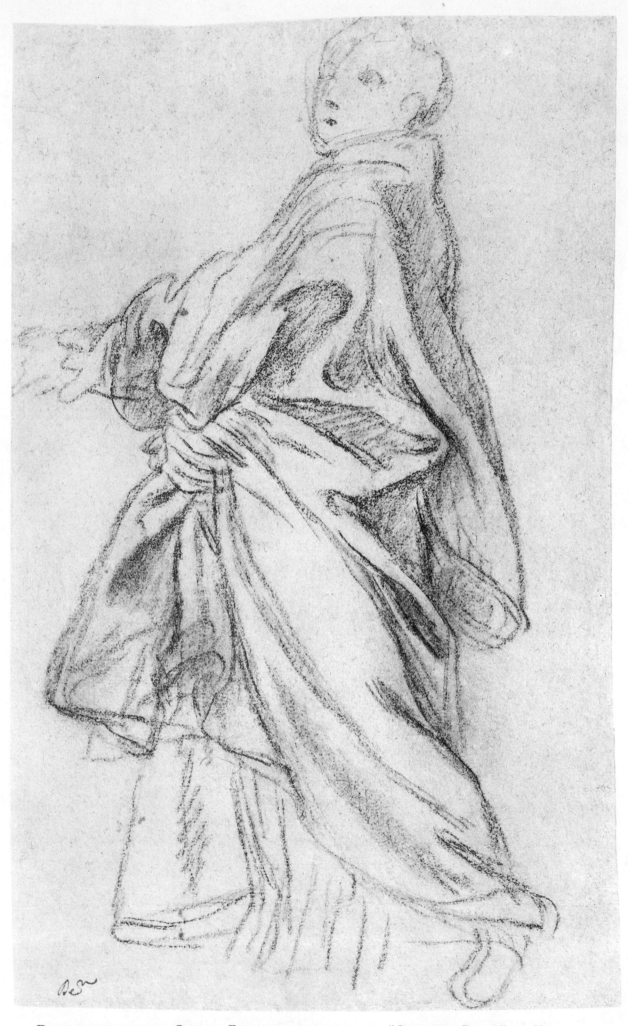

74 DRAPERY STUDY FOR A CHURCH FATHER SUPPORTING THE "CATHEDRA PETRI," c. 1660

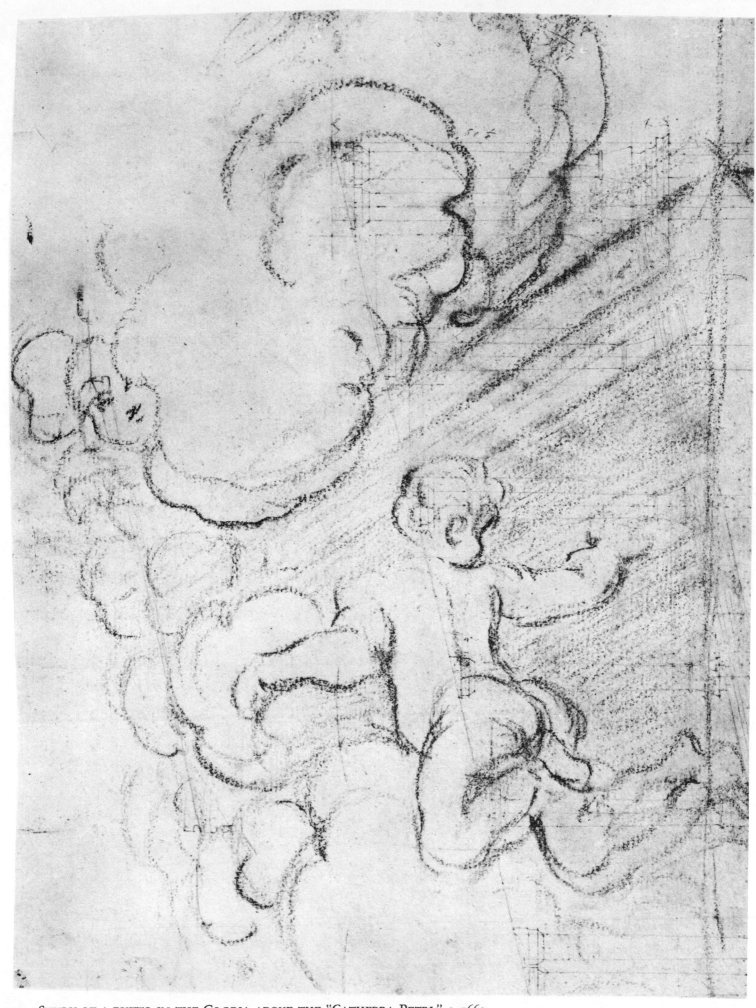

75 STUDY OF A PUTTO IN THE GLORIA ABOVE THE "CATHEDRA PETRI," C. 1660

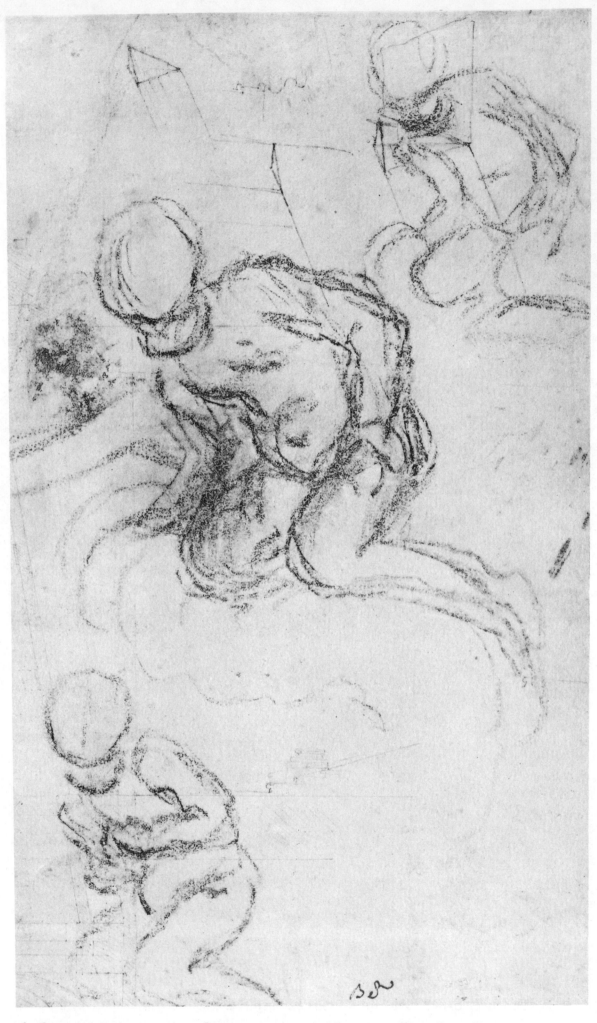

76 STUDIES OF PUTTI IN THE GLORIA ABOVE THE "CATHEDRA PETRI," c. 1660

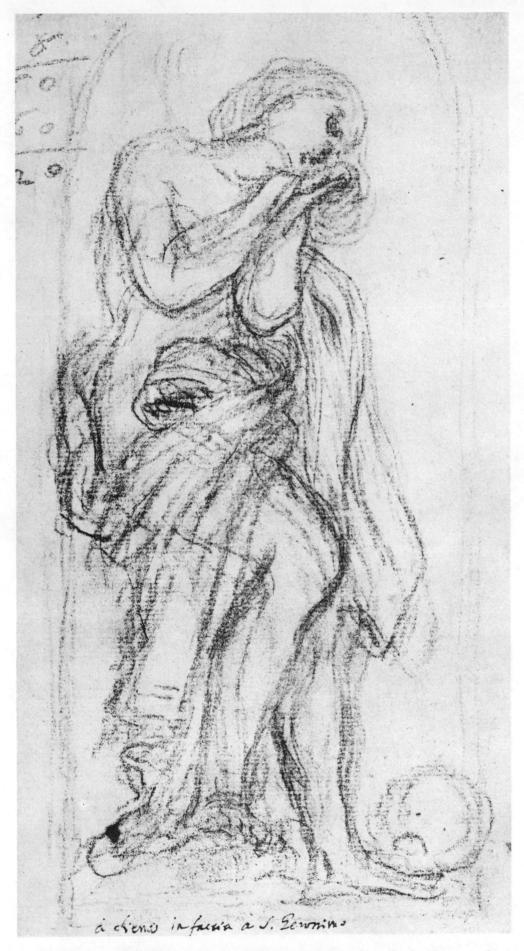

à Siena in faccia à S. Gerolimo

77 STUDY FOR THE STATUE OF THE "MAGDALENE" IN THE CHIGI CHAPEL, SIENA
CATHEDRAL, 1661

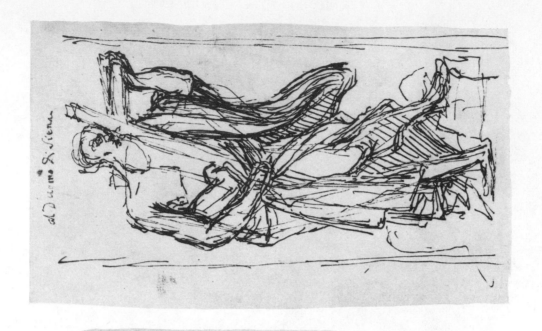

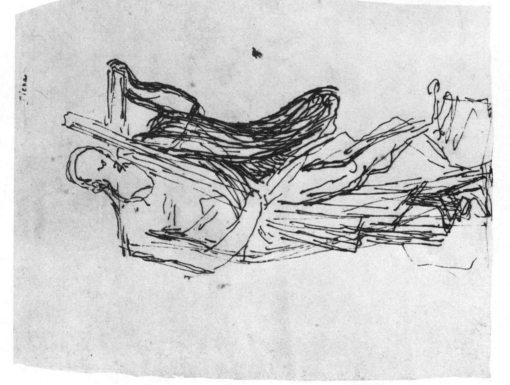

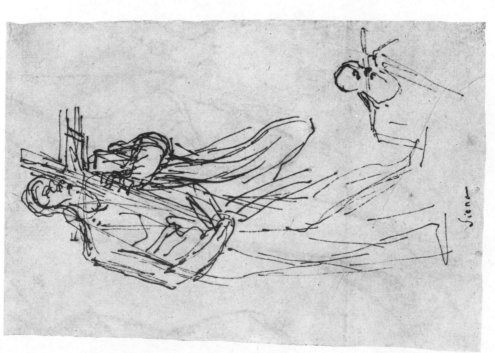

78 Three studies for the statue of "St. Jerome" in the Chigi Chapel, Siena Cathe-
dral, 1661

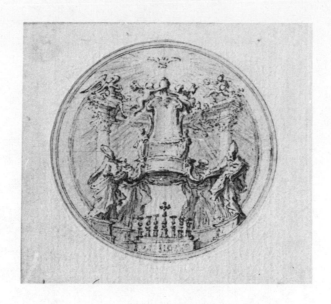

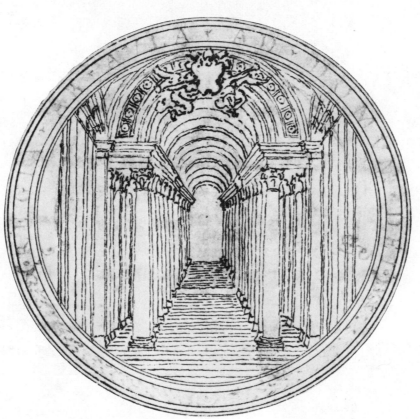

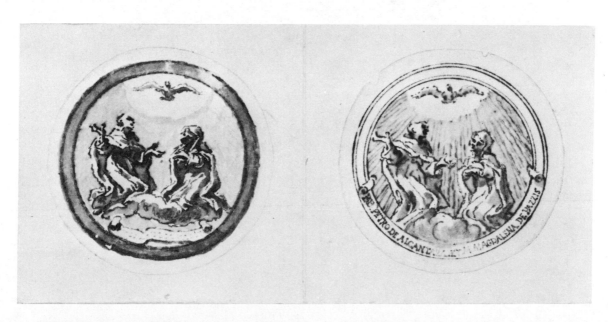

79 Design for the "Annual Medal" of 1662; design for the "Annual Medal" of 1663; and two designs for a medal commemorating the canonization of Sts. Peter of Alcantara and Mary Magdalene Pazzi, 1669

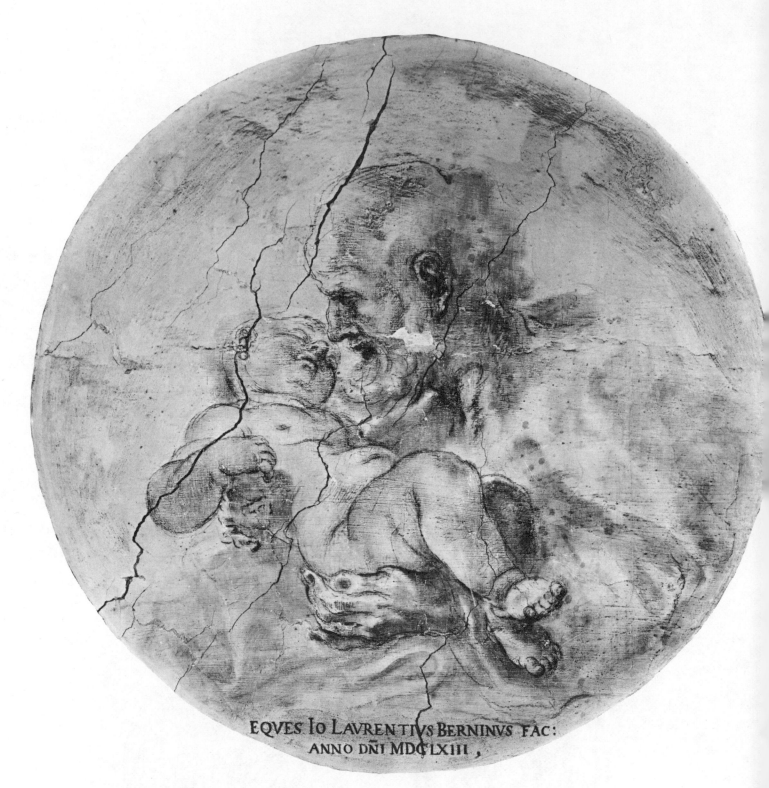

EQVES Io LAVRENTIVS BERNINVS FAC:
ANNO DÑI MDCLXIII .

80 ST. JOSEPH AND THE CHRIST CHILD, 1663

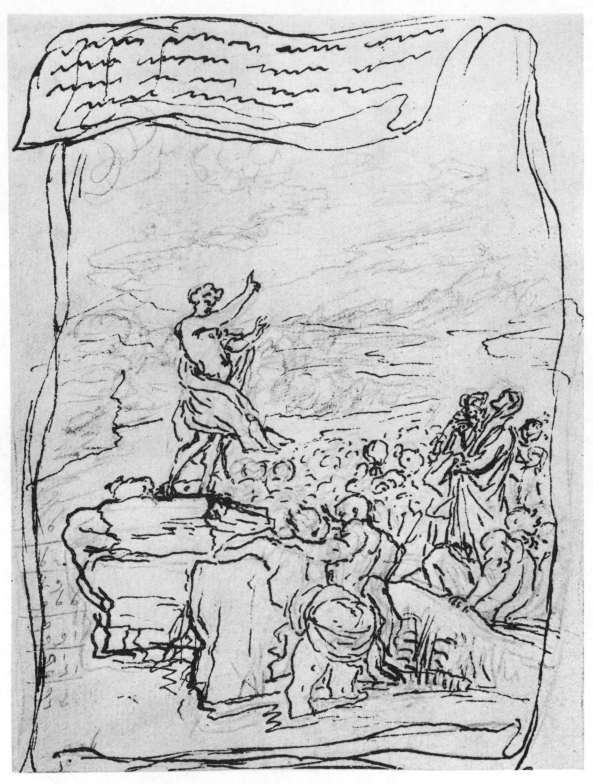

81 DESIGN FOR A FRONTISPIECE TO THE SECOND EDITION OF PADRE GIOVANNI PAOLO OLIVA'S
"SERMONS," 1664

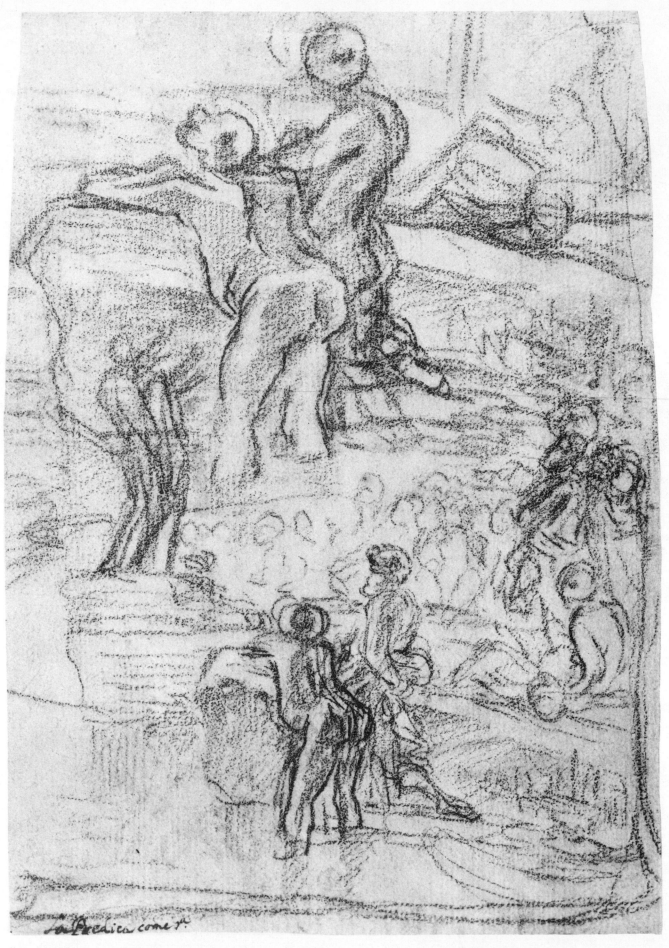

il Predica come p.e

82 STUDY FOR THE RIGHT FOREGROUND OF THE FRONTISPIECE DESIGN FOR PADRE OLIVA'S "SER-
MONS," 1664

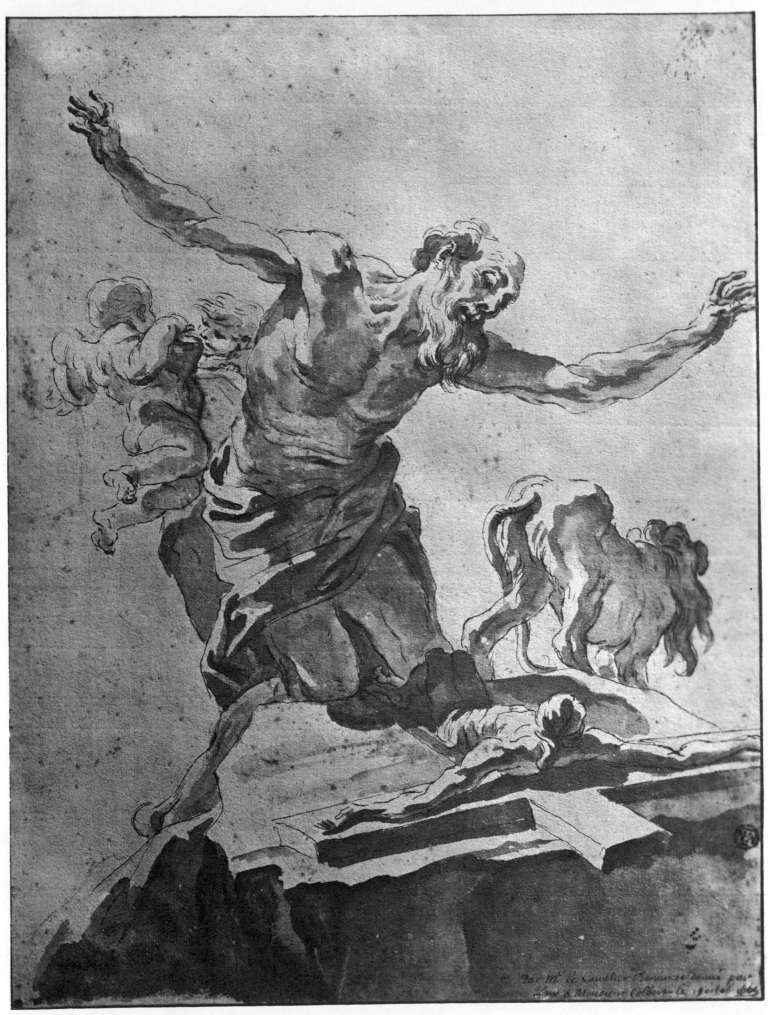

83 ST. JEROME PENITENT, 1665

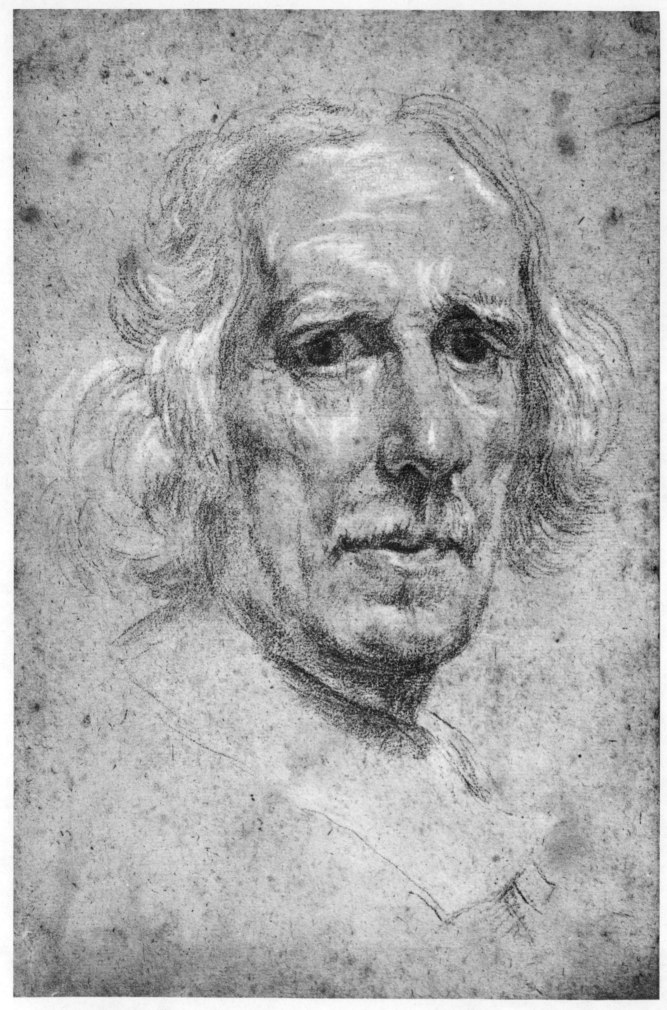

84 SELF-PORTRAIT, C. 1665

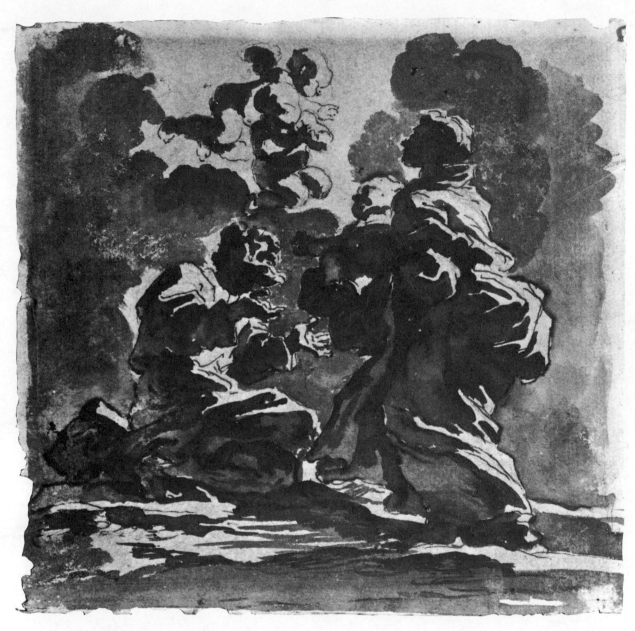

85 THE HOLY FAMILY, 1665–70

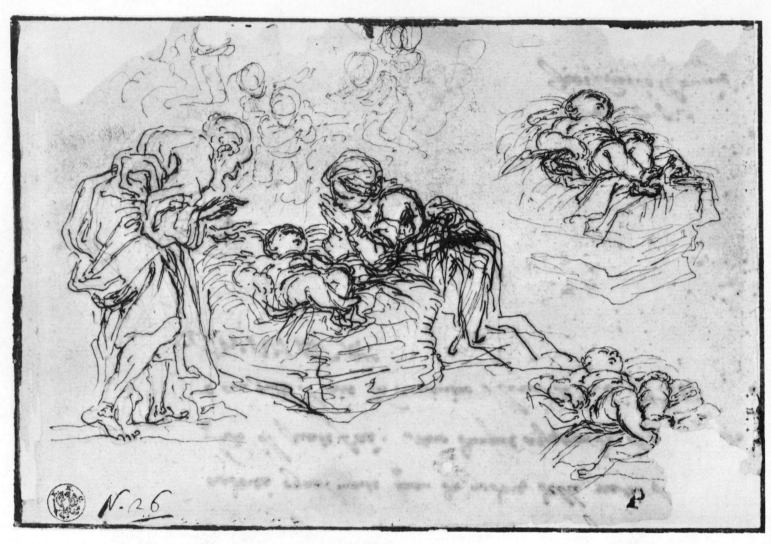

86 THE VIRGIN AND ST. JOSEPH ADORING THE CHRIST CHILD, c. 1667

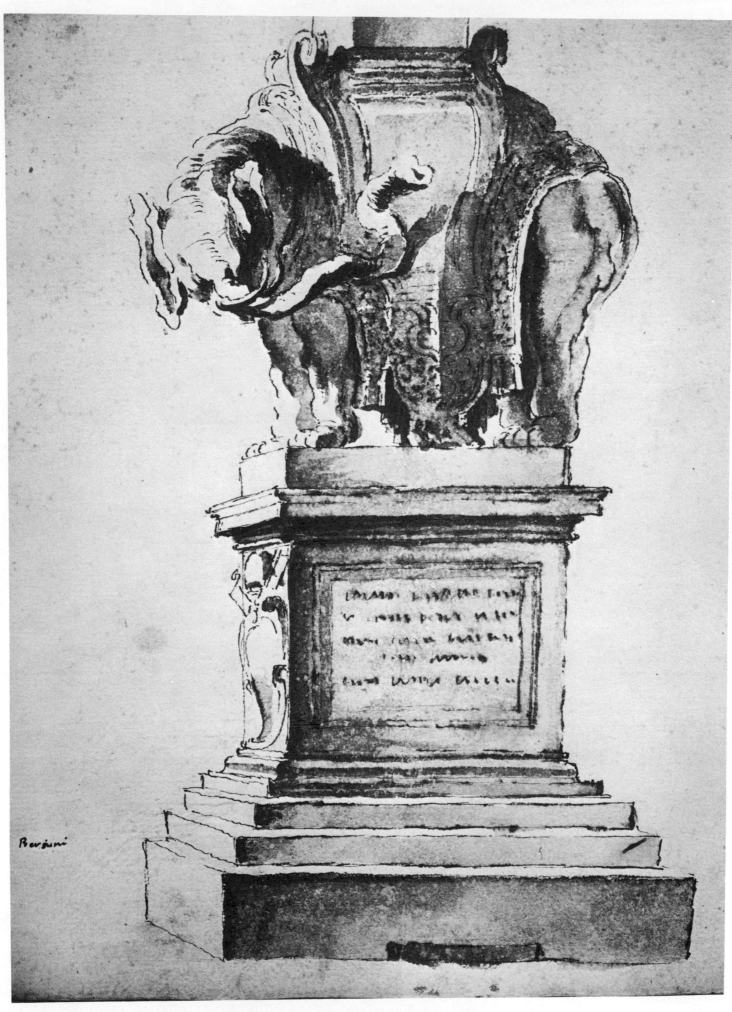

87 STUDY FOR THE ELEPHANT AND OBELISK IN PIAZZA DELLA MINERVA, 1666–7

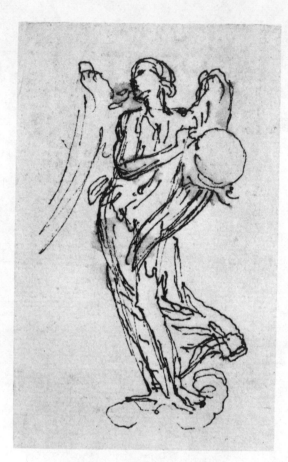

88 ANGEL WITH THE CROWN
OF THORNS, 1667–8

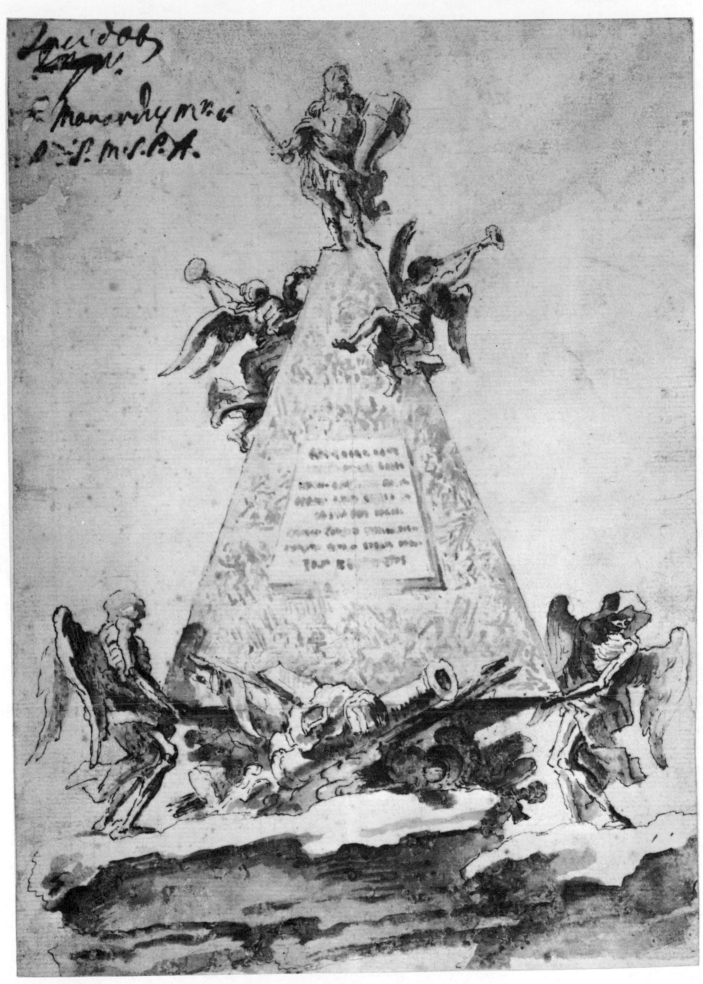

89 DESIGN FOR THE "CATAFALQUE OF THE DUKE OF BEAUFORT," 1669

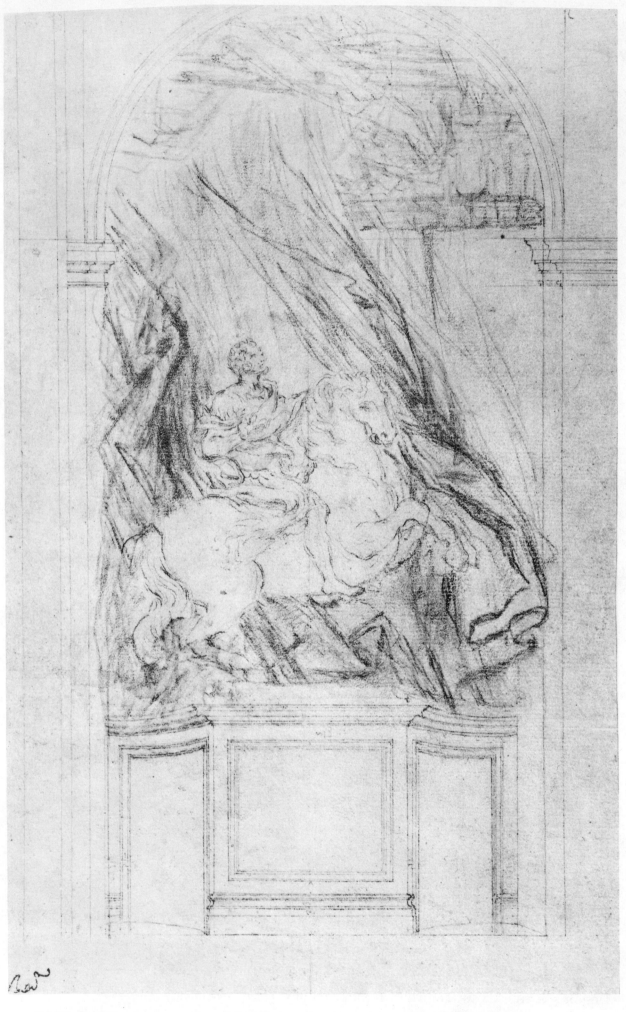

90 STUDY FOR THE FALL OF DRAPERY BEHIND THE "EQUESTRIAN MONUMENT OF CONSTAN-
TINE THE GREAT," 1669–70

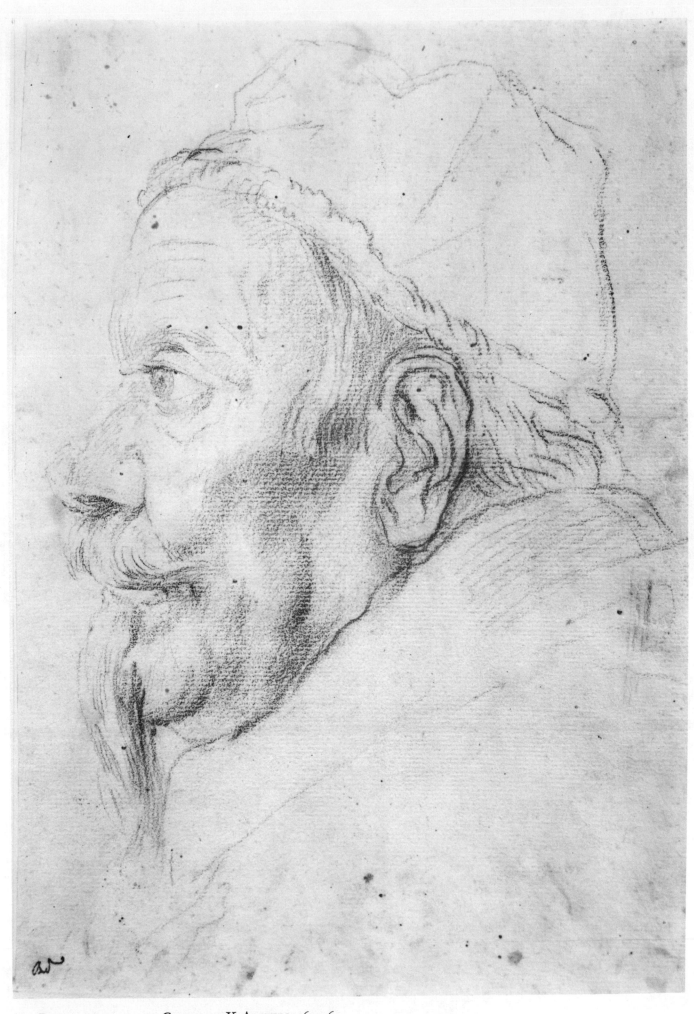

91 PORTRAIT STUDY OF CLEMENT X ALTIERI, 1670–6

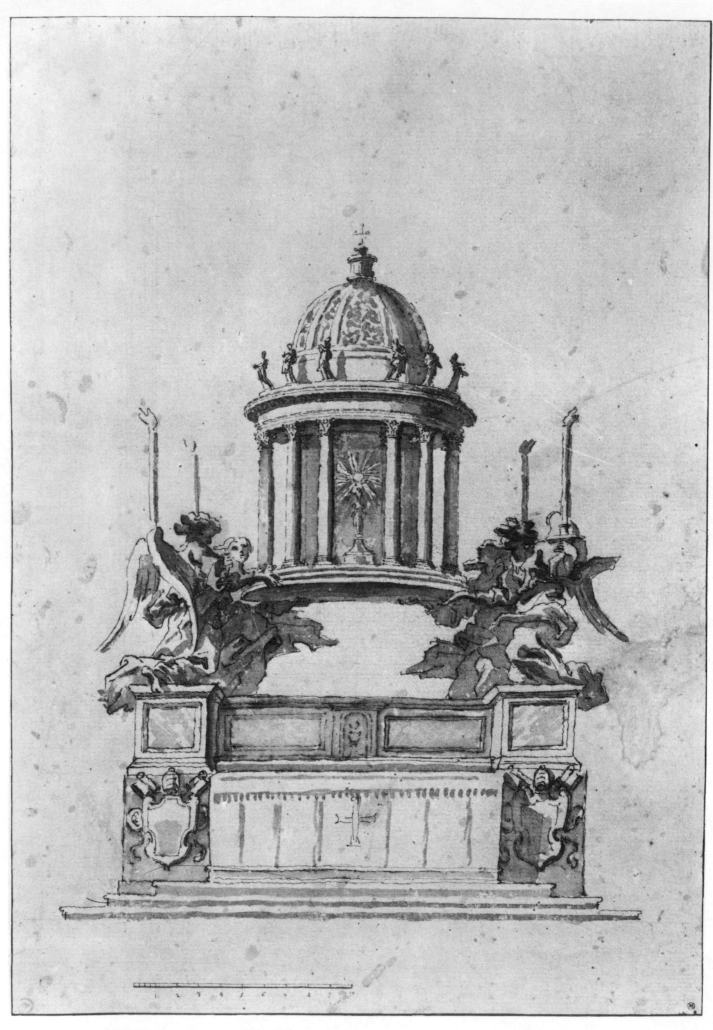

92 DESIGN FOR THE "ALTAR OF THE HOLY SACRAMENT," 1673-4

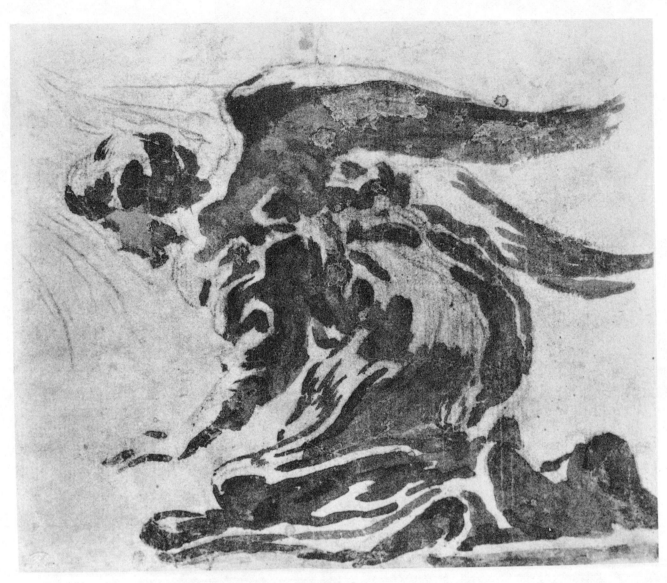

93 STUDY FOR AN ANGEL ON THE "ALTAR OF THE HOLY SACRAMENT," 1673–4

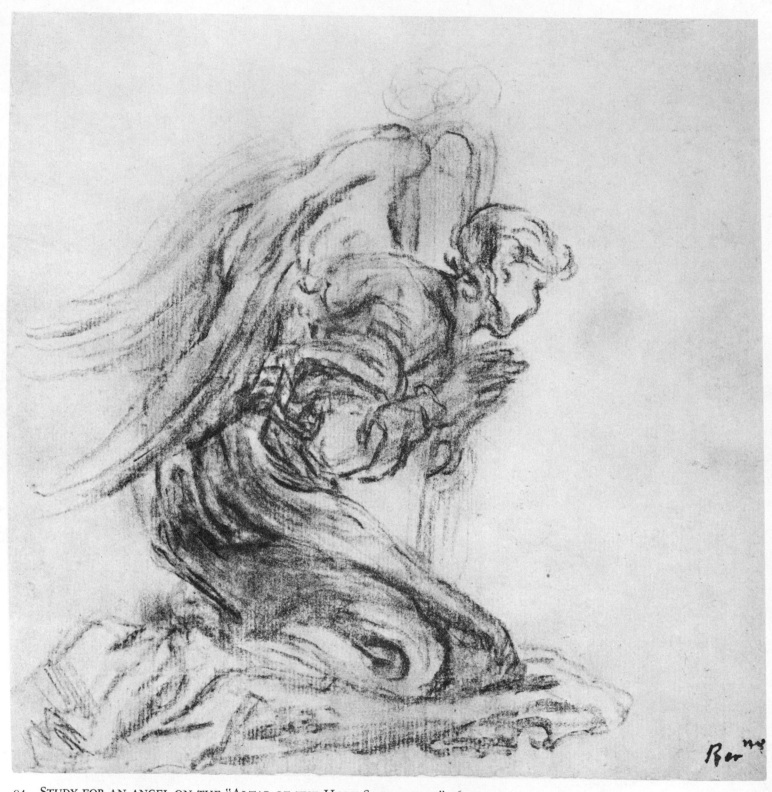

94 STUDY FOR AN ANGEL ON THE "ALTAR OF THE HOLY SACRAMENT," 1673–4

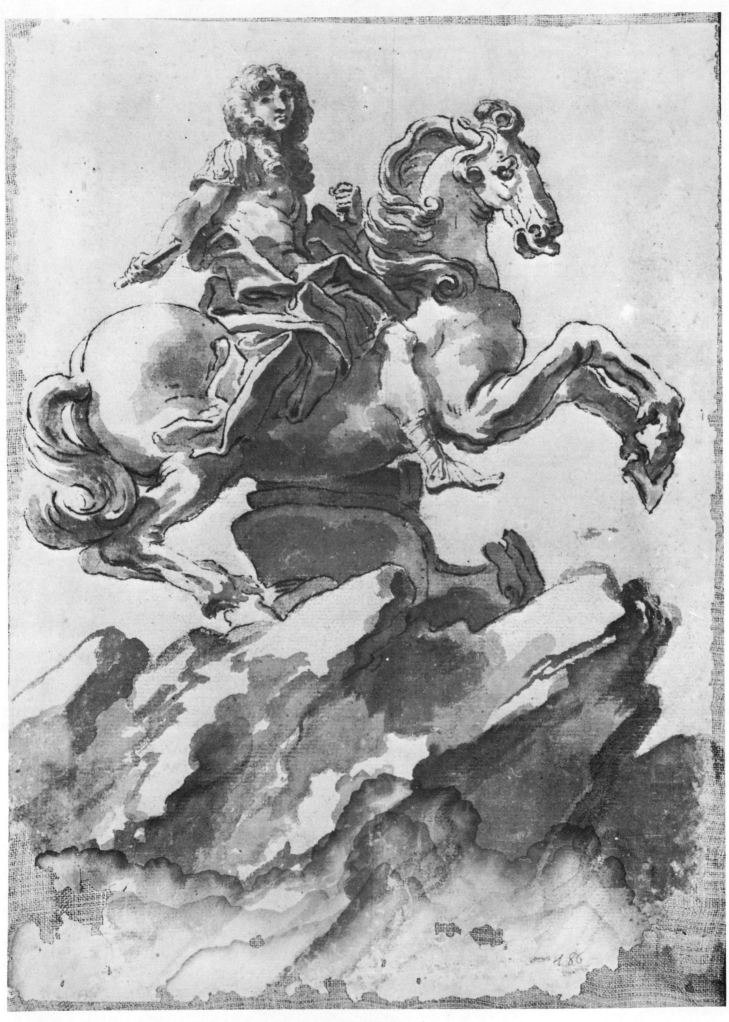

95 DESIGN FOR THE "EQUESTRIAN MONUMENT OF LOUIS XIV," c. 1673

96 ST. JEROME PENITENT, c. 1673

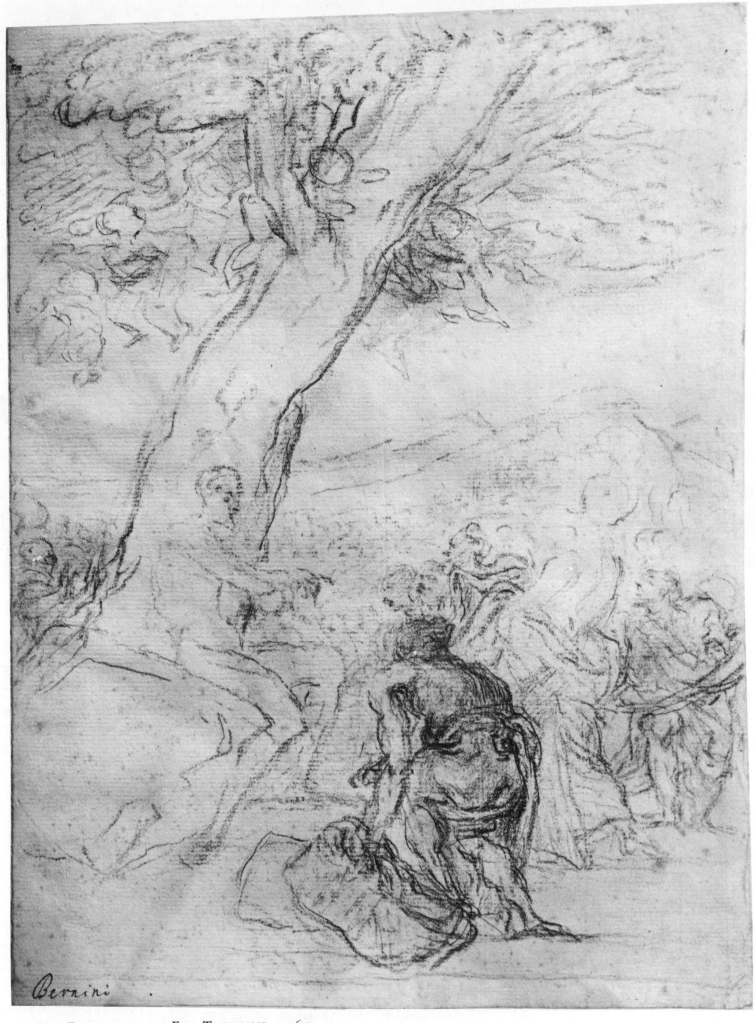

Bernini

97 THE FEEDING OF THE FIVE THOUSAND, c. 1677

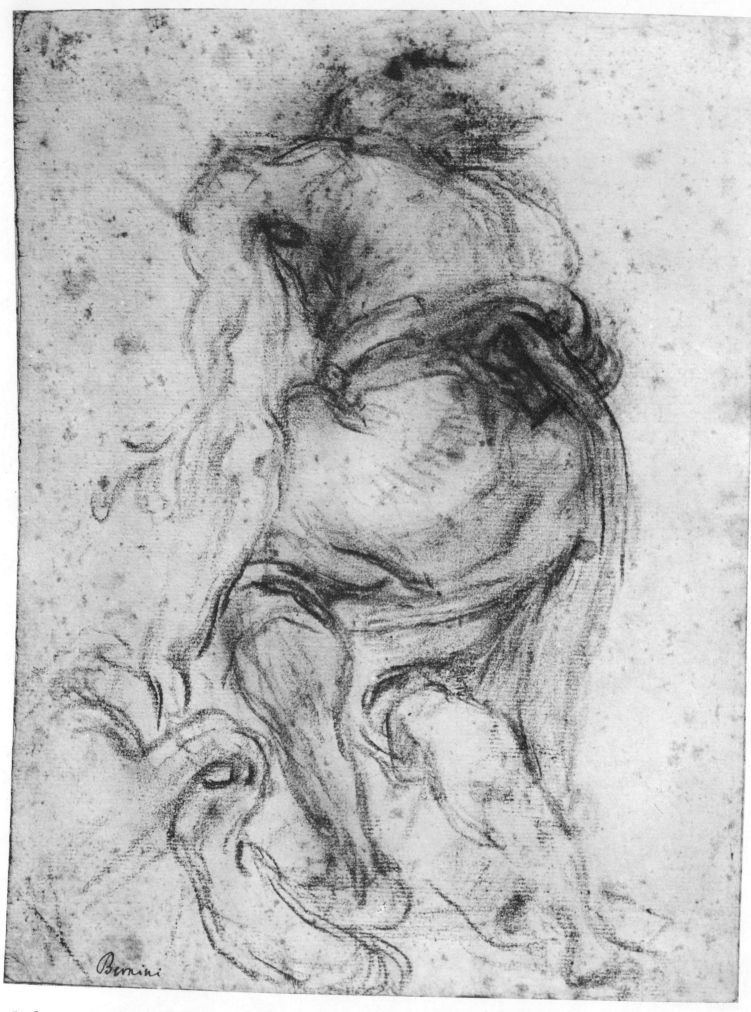

Bernini

98 STUDY OF A MAN WITH A BASKET FOR "THE FEEDING OF THE FIVE THOUSAND," C. 1677

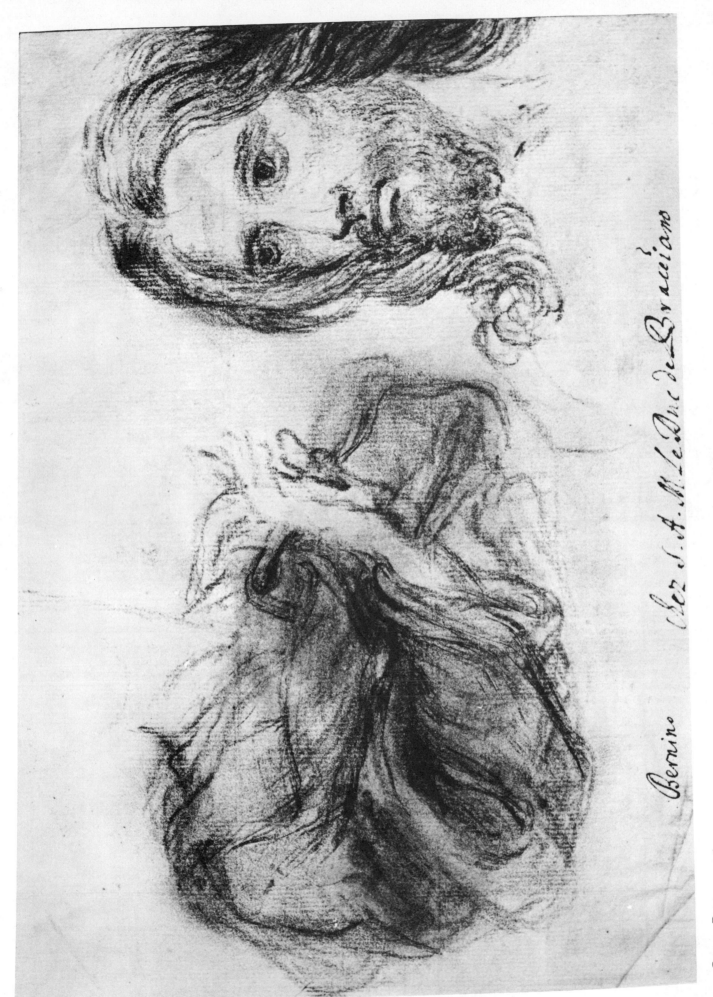

Bernino

Ser S A M le Duc de Bracciano?

99 CHRIST BLESSING, 1677

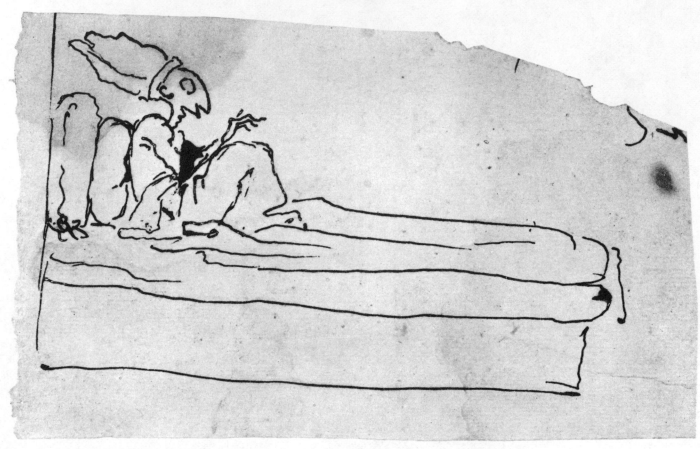

100 CARICATURE OF INNOCENT XI, 1676–80